MODERN *Calligraphy* FOR KIDS

MODERN Calligraphy FOR KIDS

A Step-by-Step Guide and Workbook for Lettering Fun

SALLY SANDERS

ROCKRIDGE PRESS

For my parents

Interior and Cover Designer: Jami Spittler
Art Manager: Amy Burditt
Editor: Clara Song Lee
Production Editor: Erum Khan

ISBN: Print 978-1-64152-381-3

CONTENTS

A B C

G H

L M

Q R S

Introduction

Welcome to the art of calligraphy! As a calligrapher, artist, and designer, I am excited to share this art form with you. Calligraphy means "beautiful writing." It comes from the Greek words *kalli*, meaning "beautiful," and *graphos*, meaning "writing." We calligraphers add beauty to our world any chance we get. It is an ancient art form that is still popular today because of its power to transform words into art. When I first tried calligraphy, I immediately fell in love with the feel of ink flowing onto paper. Many years later, calligraphy is still my passion. I meet up with calligraphers from all over the world, and we share new creations through Facebook, YouTube, and Instagram.

Calligraphy is different from typing and regular handwriting. In calligraphy, the letters express more than just the meaning of the words. Unlike text messages, words written by hand can take on extra beauty and self-expression. By writing words that are meaningful to you in calligraphy, you can make them important to your reader as well. This is a powerful ability.

I am excited to teach you to create your own wild and lovely calligraphy. It is so much easier than you might think! Once you master a few basic skills, you'll be on your way to creating handmade cards for your friends and family, journal pages, signs for school fundraisers or science projects, titles for school reports, handmade books . . . anything you write can be made more exciting with calligraphy!

This book will teach you three calligraphy styles: pointed brush calligraphy, monoline calligraphy, and classic calligraphy. Each style has three variations, or "hands." With practice, each one can feel as natural to you as your regular handwriting. You can go through the introductory chapters, or you can jump to chapter 6 and start creating new projects right away. Creating is the best way to learn calligraphy!

Let's get started!

One

Calligraphy Basics

Calligraphy is everywhere. Graphic designers and marketing executives use it for logos, movie posters, and book titles to make them expressive and unique. You can find calligraphy on T-shirts, invitations, mugs, cards, menus, and signs. On YouTube, Facebook, and Instagram, you can find calligraphers writing on paper, carving into sand and stone, making calligraphic sculptures, and etching into glass.

Calligraphy looks awesome, and it's super fun to learn. But before we put pen to paper, let's first learn a little about the forms and styles of calligraphy, and the terms you'll need to sound like a pro.

What Is Calligraphy?

The history of calligraphy is the history of writing. More than 5,000 years ago, people in China and Egypt started writing using pictures, called hieroglyphs. Over the centuries, different alphabets developed. Our alphabet is called the Roman, or Latin, alphabet. It is one of many modern alphabets with rich traditions of calligraphy, along with Arabic, Hebrew, and Russian.

Ancient manuscripts from the Middle Ages were written in fancy calligraphy. Trained scribes wrote each book by hand, one letter at a time. They dipped feather quills into ink and wrote on sheets made out of reeds or animal skin. It took a long time to write this way, so books were rare and precious. The invention of the printing press in the mid-1400s drastically changed the way books were produced. Calligraphy faded away until centuries later when it was rediscovered and became popular as an art form.

Today, calligraphers get inspiration from ancient handwritten books, calligraphic work in other alphabets and cultures, and each other. New ideas are exploding in the world of calligraphy, and you can be a part of it. Your perspective and new ideas will help carry this modern art form with ancient roots into the future.

CALLIGRAPHY IS GOOD FOR YOUR BRAIN!

Ever feel "blah" after too much time on your phone or computer? There's a reason for that. Your brain likes to be engaged in active mental and physical tasks. Calligraphy is both at the same time. Your brain must pay attention to detail and use fine motor skills to create these letters. Making that downstroke, curving your flourish, and applying the right amount of pressure will give your brain a workout. Writing calligraphy also uses the parts of your brain that focus on memory and creative thinking. So in addition to being an impressive new skill, calligraphy energizes your brain, expands your creativity, and improves your memory!

Is Hand-Lettering the Same as Calligraphy?

Hand-lettering and calligraphy can look very similar. How do you tell them apart? It helps to think of hand-lettering as *drawing* letters and calligraphy as *writing* letters.

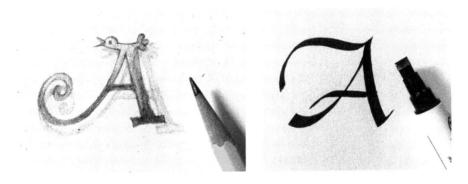

Hand-lettering artists draw each letter as a little illustration that fits into a unique design and use just about any type of art materials. By contrast, calligraphers write letters with special tools that produce thick strokes and thin strokes to form the letters.

Forms

Lettering forms are divided into three basic types: serif, sans serif, and script.

Serif Sans serif Script

- Serif letters have small extending features at the ends, or "terminals," of each main line or stroke, like little feet or hats for each letter. This sentence is written in a serif font—do you see the serifs?
- Sans serif letters have plain terminals to each stroke—"sans" means without, so this name simply describes a letter without serifs. This sentence is written in a sans serif font—can you see the difference?
- Script refers to letters that are joined together, like cursive handwriting, to form continuous fluid words. *Like this sentence.*

Styles

In this book, we will learn three of today's popular calligraphic styles: pointed brush calligraphy, monoline calligraphy, and classic calligraphy.

Pointed brush calligraphy has a very modern feel. It is formed with thick strokes and thin strokes that are made by using more or less pressure on the brush tip. The brush is the most versatile writing tool. We can use it to write a delicate and graceful script, or a rough, expressive shout!

Monoline calligraphy does not have thick strokes and thin strokes. All the strokes of each letter have the same thickness from

YOU CAN DO THIS!

Prepare your zone. Start out slowly, have your supplies handy, and find a quiet, uncluttered work space.

Focus your efforts. Choose one or two favorite styles to master first, rather than trying too many at once.

Learn to see the letters, not just write them. Calligraphy requires training yourself to view letters in a new way. Take time to notice the shape of each letter, including its white spaces, and the overall look of the alphabet.

"Oops!" means "opportunity." We learn from every mark we make, even mistakes. Each mark is a chance to practice, improve, or maybe even create an interesting variation for the future.

Be kind to yourself. See a letter that needs work? Great! You are learning to see like a calligrapher. That is an important step!

Be patient with yourself. Go slowly. Give yourself all the time and practice you need. Frustrated? Take a deep breath, stand up, rest your hand, and start fresh.

INTERVIEW WITH DÀO HUY HOÀNG, PART 1

I would like to introduce you to Hoàng, a young calligrapher in Hanoi, Vietnam. We met on Facebook through sharing our calligraphy.

When did you start learning calligraphy?

I started calligraphy eight years ago, during my first year of college.

What sparked your interest in letters and writing?

I have always loved handwriting. My grandfather taught me to write in Vietnamese and Chinese when I was little, and he kept inspiring me throughout my childhood with his beautiful notebooks and those of his father—my great-grandfather. During my graphic design studies, I was really into lettering. But I quickly realized that computer work was not for me. That is when I turned to hand-lettering and calligraphy.

Where do you write, and how do you organize your work space?

I live in a small apartment in Hanoi. My work space is the living room. I have an architect table for daily practice and commissions. My books and supplies are all around me so that I can quickly access them for study or research.

What is the most important tip you can give to someone who is just starting out in calligraphy?

Be patient and study historical scripts! I believe we need to know how our ancestors wrote before we can create our own work.

continued on page 15

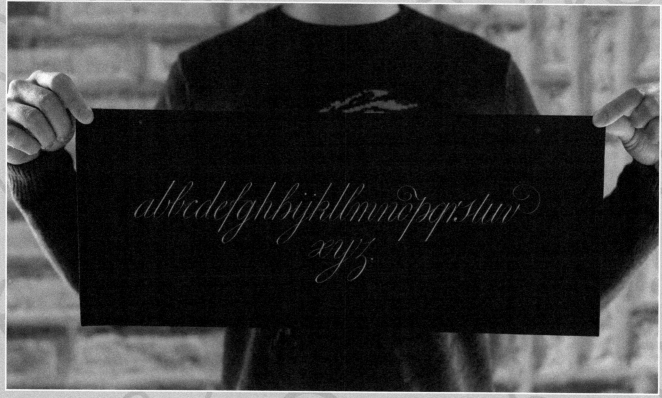

beginning to end. It tends to look simpler than the styles with the thick and thin strokes. It has a distinctive appearance that can be used in a variety of projects.

Classic calligraphy is what people typically picture when they think of calligraphy. It is written with a special chisel edge pen that has a broad, flat edge (in chapter 2, we'll talk more about the pens). Controlling the angle of this edge on the paper forms thick and thin strokes. Classic calligraphy often uses serifs (the little feet and hats for each letter) and is based on historical calligraphy. It almost always feels special and elegant.

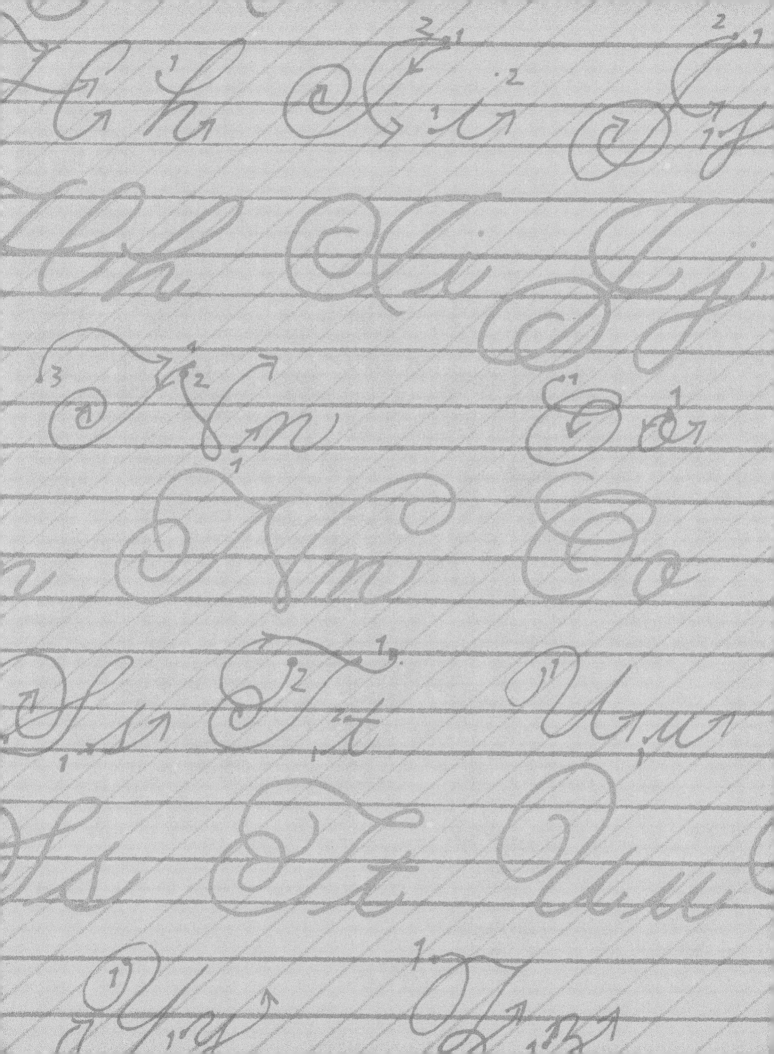

Two
Pens, Papers, and Preparation

Every artist knows that preparation is the first step in beginning a new project. Before you put pen to paper, let's go over how to set up your writing space, what materials work best (hint: they might be simpler than you think!), and how to use this book to learn the essentials of calligraphic art.

Calligraphers can use many different kinds of tools, but starting out is simple: You need a nice pen or brush, a quality piece of paper, and a quiet place to work. You may also want a ruler to line your paper, a pencil to make those lines, and an eraser to erase them when you're done. Using the right materials will set you up for success. As you create more projects, you can expand your collection of tools, but this is all you need to get started.

Create Your Work Space

Every artist needs a studio, even if that studio is just a space on your kitchen table. Make sure your work space is well-lit and free from distractions. Creating calligraphy is different from writing in a journal or eating a meal; you want to make sure you're positioned high enough in relation to your drawing surface, and you may find your regular chair is too low. You can try adjusting your height with a pillow or book, or by sitting on a stool. You want to be high enough that your writing arm rests lightly on the table surface. This will allow your arm to move freely as you write. Sitting up straight will help energize your letters.

Chisel Edge Brush Tip Bullet Tip

Writing Tools

This book will teach you to use brush tip, bullet tip (or round), and chisel edge marker pens, which are easier to manage than some other tools and don't require separate ink or paint. Make sure you get markers that are odorless and nontoxic! You'll need markers that make crisp lines and can stand up to a lot of writing. Here are some of my favorite marker pens, which you can find online or at your local art supply store.

POINTED BRUSH MARKER PENS (BRUSH TIP)

Many brush tip markers come with both a brush end and a fine tip marker end. These are great for practicing brush writing with one end and fine embellishments or monoline writing with the other. Make sure you find one with a firm tip that will allow you more control over your thick strokes and thin strokes. My favorites are:

Tombow Dual Brush Pens. These are great for practice writing. They are water-based, the colors blend nicely, and the brushes are flexible and sturdy. The sets come in different color palettes.

Crayola Brush and Detail Dual-Tip Markers. These are a little less expensive than the Tombows but are still very good. They also have two tips: a brush tip and an ultra-fine tip. They are good for practice writing. They come in sets of 16, and the fine point tip ends are a lighter color than the brush ends—that gives you 32 colors!

Sakura Koi Watercolor Brush Pens. These pens come in different palette sets. They have good tips and fun colors, and they blend well. I really like using the grays set.

Tombow Fudenosuke Brush Pen. This pen is great for smaller writing. It comes in a two-pack with both a soft and a hard brush pen.

Various Chinese Lettering Brush Sets (black, four to six pens per set). You can find smaller size brush tips made by Chinese brands like iBayam, Misulove, and Boxun. These pens are inexpensive, can be refilled, and are perfect for small writing.

MONOLINE MARKER PENS (BULLET TIP)

The easiest pen to find is a monoline lettering pen. You just want a regular bullet tip marker. Make sure the pen is a good size—fine tip pens are hard to work with, and large bullet tips will show through your practice pages. I don't recommend Sharpies unless they are water-based.

If you have any of the dual tip brush sets discussed (see page 10), you already have fine tip markers on one end of them!

Crayola Broad Line Markers. These are regular Crayola markers that you might already have in your house. They work great for practice.

Pentel Color Markers. I always have this set in my studio. I love their ink flow, brilliant colors, and affordable price. Their tips are fine, but not super fine, making them perfect for monoline lettering projects.

CLASSIC CALLIGRAPHY MARKER PENS (CHISEL EDGE)

Look for chisel edge calligraphy markers with tip sizes 3.5 mm and 2 mm. They come in lots of colors and last a long time. You'll want to buy two or three marker pens so you have a backup when the ink dries out or the tip becomes mushy.

Kuretake Zig Calligraphy Pen Sets (water-based ink). This is my favorite set. These have a 3.5-mm tip on one end and a 2-mm tip on the other. They last a long time and have great colors.

Yasutomo Y and C Calligraphy Markers (water-based, chisel edge, assorted sizes, black, three-pack). This set has three single tip markers in a dense black acid-free ink, sizes 2 mm, 3.5 mm, and 5 mm. These are the perfect sizes for our practice pages.

Kuretake Zig Memory System Calligraphy Marker. I always have a few of these in pure black in my studio. They work for both extra-large writing and small writing because their tips are 5 mm on one side and 2 mm on the other. You can buy individual black markers or packs of six. The larger end is too big for our practice pages, but the smaller tip works great!

Paper

The paper you write on makes a huge difference for your calligraphy, in both appearance and your ability to control your thick and thin strokes. You want your paper to be smooth and bleed-proof because you are using marker pens. A smooth surface allows your marker tips to glide across the page. You want to avoid paper that soaks up too much ink and "bleeds" color along the edges of your lines because it will make your letters look fuzzy. Paper with too much texture will damage your marker tips.

There are many art papers that work well for calligraphy. Even some regular paper, like copy paper or some notebooks, works well for practicing. Check the supplies you already have to see if they work with your markers. Make sure to test them out first! You might find that a sketchbook with thick paper works great for drawing but doesn't work well for your calligraphy. Remember, you are looking for a smooth surface that allows your marker pens to leave crisp, clean lines.

LOOSE-LEAF PAPER

HP Printer Paper, Premium32. This is regular printer paper that you might already have at home. It is a nice weight, is smooth, and won't cause your markers to bleed. It is perfect for lots and lots of practicing.

Rhodia Black Dot Pad, Number 19. This paper is semi-transparent and has a small dotted grid for easy guidelines. It is another great practice paper.

Canson XL Marker Paper Pad, Semi-transparent. You can see your guidelines through this paper, which is great for practice. It is smooth and bleed-proof.

Strathmore Series 400 Sketch Pad. This is quality paper and can be used for your finished final works of art or for a journal. It is not see-through, so you'll need to draw your guidelines.

Pacon Semi-transparent Tracing Paper or Darice Studio 71 Tracing Pad, 9 x 12 inch. If you want to extend the life of your practice pages, you can tape a sheet of tracing paper on top of your page and write on that to give you more opportunities to practice the sample letters. Tracing paper is also great when designing projects.

JOURNALS AND SKETCHBOOKS

Canson XL Mix Media Paper Pad. This blank paper notebook comes in all sizes and is great for a journal.

Strathmore 500 Series Mixed Media Art Journal. This paper also comes in various sizes and is great for wet or dry projects.

Rhodia Black Dot Pad, 8¼ x 11¾ inch. This pad has dotted pages and is super fun for calligraphy. You never have to draw guidelines—just use the dots! Use them horizontally, vertically, or even diagonally. It is great for figuring out calligraphic borders, too.

A Few Extras

Even though all you really need is a marker pen and paper to get started, you may want a few additional tools in your calligraphy toolbox. These items make it easier to create your projects, and the good news is that you may already have some of them around your house.

Pencil. A Number 2 is fine as long as it's very sharp. Even better is a mechanical pencil with 5- to 7-mm lead. You will use a pencil for drawing guidelines, figuring out flourishes, bouncing letters, and designing projects.

Prismacolor Premier Kneaded Rubber, Artgum, and Plastic Erasers (three-pack). The eraser on the back of your pencil usually does more harm than good. Try out these artist erasers instead. The kneaded eraser can carefully lighten a penciled illustration before inking or painting it, the artgum eraser is great on soft papers and large areas, and the plastic eraser works for almost everything.

Pentel Retractable Clic Eraser (three-pack). These thinner pen-like erasers are great for carefully erasing small details without smudging your calligraphy.

T-square. This tool is for drawing guidelines. I cannot live without my T-square. Get the 12-inch if you plan on working small, or get the 18-inch for both small and larger projects. Here are some good ones:

- Ludwig Precision Aluminum 18-inch Standard T-Square
- Alvin ALT Series, 12-, 18-, or 24-inch Aluminum Graduated T-Square

Acrylic Paint Markers, Medium Tip by Artistro. These are just for fun. You can write on any material with them to create a T-shirt slogan, personalize your water bottle, or write something inspiring or silly on a rock for a friend.

Posca Paint Pens by Mitsubishi. These bullet tip markers don't bleed on paper and can overwrite on themselves without showing the color underneath.

Colorbök Cardstock Papers. These thick papers are smooth and strong, and come in an amazing array of color choices and patterns for any project you might think up. You can buy single sheets at Michael's or Joann fabric and craft stores. Patterned 12-x-12 inch sheets are great for the projects in chapter 6.

As you continue in your study of calligraphy, you will find the following two companies very helpful. They are dedicated to the study of calligraphy and related arts, and are important sources for supplies, information, publications and books, and advice. These companies are online, have the best calligraphy supplies, and are super friendly and knowledgeable:

Paper & Ink Arts: PaperInkArts.com
John Neal Bookseller: JohnNealBooks.com

continued from page 5

INTERVIEW WITH DÀO HUY HOÀNG, PART 2

Do you have any specific warm-up routines when you sit down to write?

I do a lot of doodles and drills before actually writing. I do large arm movements and hand movements to get the blood flowing and to relax my hands. I like the Palmer Method drills; I think they are super fun and easy to follow. You can find these drills online with a Google search.

What is one of your favorite pieces/projects/commissions you have done, and why did you like it so much?

I did a series of *Lord of the Rings* poems for a client in various calligraphy styles. I loved that project because the client allowed me a lot of freedom. The client didn't ask anything of me but my own creative artistic interpretation.

How has the study of calligraphy enlarged your view of the world, or added experiences and friendships to your life?

I am very lucky to be asked to travel around the world to teach and study calligraphy. Since 2015, I have visited cities in 10 different countries. My calligraphy travels have given me new and interesting friends, new cultural experiences, and unique people to study with.

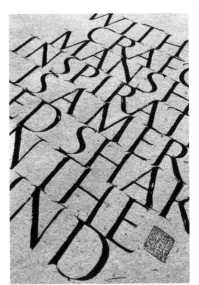

Want to see more? You can visit Hoàng's work and store here: HuyHoangDao.com

Know the Strokes

No matter what style of calligraphy you're using, start by breaking down the letters into separate individual strokes. Letters are all built from a small number of common shapes. Each stroke is a building block, and each letter is made up of different blocks.

Here are the basic calligraphy strokes:

Downstroke: A stroke made by moving the pen or brush downward on the paper; this stroke is usually thick.

Overturn: A type of stroke (starting or within a letter) where the line changes from thin to thick as it turns.

Crossbar: A thin horizontal stroke used in letters like "t" and "A."

Upstroke: A stroke made by moving the pen or brush upward on the paper; this stroke is usually thin.

Underturn: A type of stroke (finishing or within a letter) where the line changes from thick to thin as it turns.

Compound curve: A stroke joining the exit from one letter to the entrance of the next; a compound curve can also be a form within a letter.

Using the Practice Pages

Calligraphy is easy, but it takes practice. The more you write, the happier you will be with your calligraphy. Each time you practice, your muscles become more familiar with all these new movements. Soon the turns, curves, upstrokes, and downstrokes will be ingrained in your muscle memory, and your brain won't have to focus on every tiny movement.

Calligraphers also rely on **guidelines**. They are like a secret measurement code for letters. This calligraphy code uses words like "x-height," "nib width," and "waistline." These terms might not make any sense to an outside observer, but you'll soon know what they mean. The practice pages in this book have guidelines that tell you all the information you need for your writing to have consistent form, slope, and size. They will make your practice super easy; as you write, you won't have to guess how tall a letter should be or where the bottom of a lowercase "y" should fall. All that information is in the code. You will learn how to draw your own guidelines, too.

Let's take a look at some of the key terms.

Ascender line: The line that the tall parts of the tallest letters reach up to; the letters "b," "d," "f," "h," "k," and "l" have ascenders.

Slant line or slope line: The line that shows the slope, or how far forward the letters should lean.

Capitals line: capitals are often shorter than the ascenders

Waistline: The line that runs along the x-height of the letters.

Baseline: The line that the letters sit on.

Descender line: The line below the baseline that the lowest parts of the letters reach; the letters "f," "g," "j," "p," "q," "y," and "z" have descenders.

X-height: The height of the main part of each lowercase (or minuscule) letter; this is usually easy to see on the lowercase x (which is why it's called the x-height!). Classic calligraphy measures the x-height in pen widths.

Dealing with Mistakes

Calligraphers know all about mistakes. You could be happily writing along—and then leave out a whole line. Your pen might fall on the paper and leave a big mark, or you might make up brand-new ways to spell words. But keep on writing; mistakes happen. They're a normal part of the process.

Change how you feel about messing up. Calligraphy is not about perfection; it is about beauty. Every mark you put on the paper is risky. It can turn out great or not so great. This risk is what art, beauty, and learning are all about. So expect to create a lot of weird letters as you learn this new skill.

Respect yourself and your work. Always leave a margin (large white space) around your work to set it off, like a frame. Don't ruin your hard work by crossing out your mistakes. Treating your work with respect in this way also shows respect for your time, diligence, and progress. Keep in mind that you might be the only person who notices your mistake. And a week ago, you might not have noticed it either—so your critical eye is actually a sign of your progress.

Plan for mishaps. Professional scribes plan to write the final version of a piece three separate times and choose the best. This helps them avoid stress about ruining something as they work. You can use this same trick to take the pressure off your own work. It might even help you make fewer mistakes than if you were anxious about getting everything right on the first try.

HEY, LEFTIES! OVER HERE!

If you are left-handed, you probably know the feeling of accidentally brushing over wet ink and smudging your work. That is because our system of writing from left to right is easier for right-handed writing. You can prevent that from happening by adjusting your strategy for holding your pen and angling your paper.

If you typically "hook" your hand above the letters to write, you will need to adjust that hold for calligraphy. This may be hard at first because you have been writing differently for years—but just think of how lucky you are to be relearning as a kid instead of as an adult! Start by pointing the right top corner of your paper down. Place your writing hand below the baseline so your whole arm is free to move with the strokes. When you use the practice pages in this book, remove the pages or make copies on good printer paper. Then place your paper flat in front of you and angle it as much as you need to.

Don't worry if this adjustment takes time and seems to slow you down. Learning calligraphy should be a slow process at first for everyone. Everything about writing calligraphy is completely new to each of us—and your pen hold might as well be new, too.

Does your arm placement feel awkward? Do your strokes look a little wobbly? Don't give up! Trust me, you can do this! There are many internationally known calligraphers who are lefties, and you can become one of them.

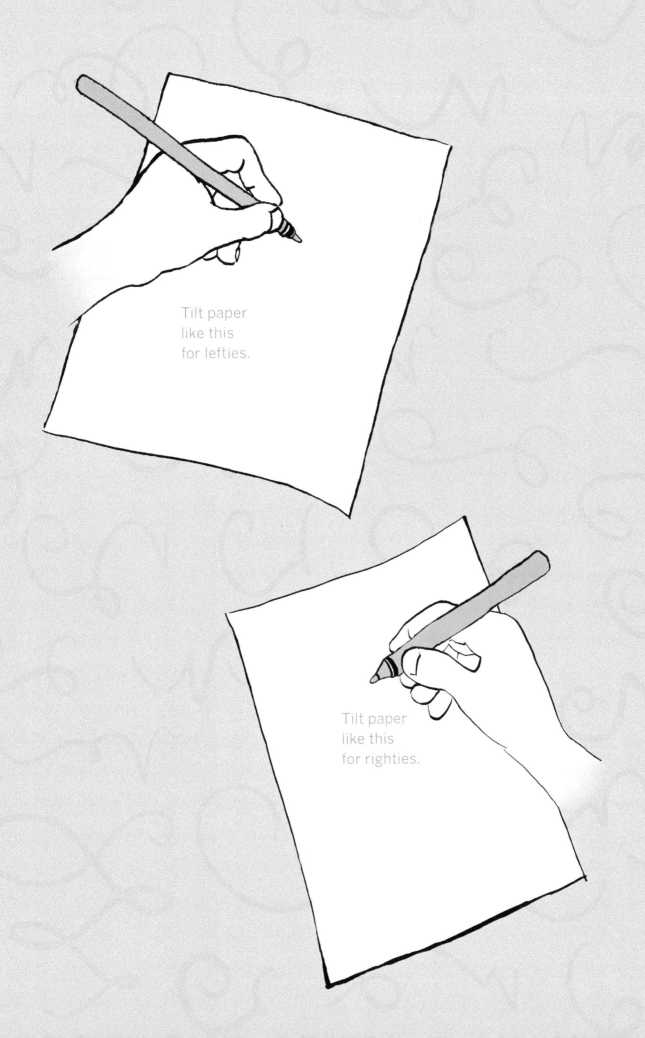

Tilt paper
like this
for lefties.

Tilt paper
like this
for righties.

m n o p q

v w x y z

4 5 6 7 8 9

D E F G

Three
Pointed Brush Calligraphy

Brush writing is as ancient as cave paintings. It has been reinvented over and over throughout history to become a dominant form of calligraphy in the twenty-first century. It can be flowing and graceful, look like an angry shout, or accentuate a sweet note to a friend. No matter what, it will always carry your message with emotion. The pointed calligraphy brush is the most versatile tool!

Walk down the card aisle at a store and look at the writing on the cards. You will see brush lettering everywhere. This book will introduce you to three different alphabets written with the brush. In this chapter, you will learn the correct pattern of pressure and release, using the full brush or just a whisper of the tip to create the letters. You will also learn how to join letters, "bounce" your writing, and add flourishes.

Here we go!

Holding Your Brush Tip Marker

You're going to move the brush in your hand a lot while you write these alphabets. You will need to tip the brush up and down, and to move your

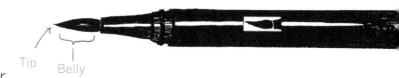

Tip Belly

hand for diagonal and horizontal strokes to get the weight (or thickness) of each stroke just right.

Check out these hand and brush holds for the different kinds of strokes:

✦ For thick strokes, use pressure and lay the brush flat on its belly.
✦ For thin strokes, tilt the brush upright in your hand and touch the paper with just the tip.

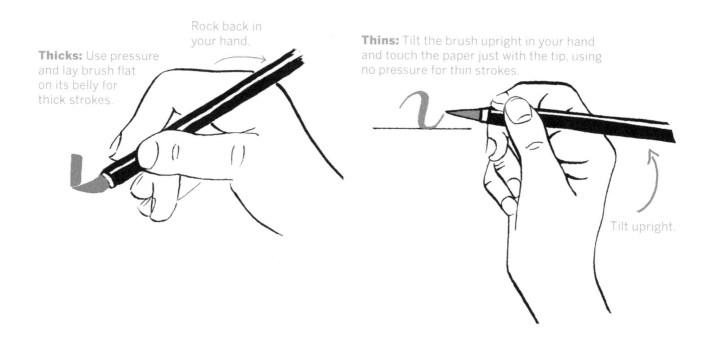

Rock back in your hand.

Thicks: Use pressure and lay brush flat on its belly for thick strokes.

Thins: Tilt the brush upright in your hand and touch the paper just with the tip, using no pressure for thin strokes.

Tilt upright.

- For horizontal crossbar lines, set your hand below the writing line and use a little pressure.
- For diagonal thick strokes, set your hand above and to the right of the letter, and use pressure and the belly of the brush.

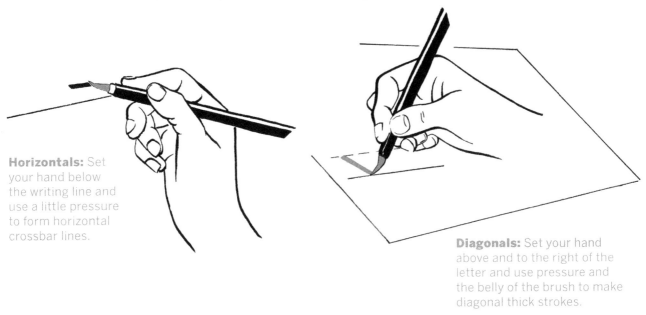

Horizontals: Set your hand below the writing line and use a little pressure to form horizontal crossbar lines.

Diagonals: Set your hand above and to the right of the letter and use pressure and the belly of the brush to make diagonal thick strokes.

Making the Strokes and Letters

The pointed brush is super flexible and sensitive, making every calligrapher's work look unique. You can be artistic and make your pointed brushwork your own. However, there are some basic elements you should include. Pointed brush alphabets are usually script or cursive. That means the letters connect with each other and have a slope—they lean forward a bit, as if they are running. For a strong and calligraphic alphabet, all of the thick strokes should have the same thickness, and all of the thin strokes should have the same thinness, the overall slope of the letters should match, and the letters should be carefully formed.

TIP: Work slowly. Each stroke will become familiar to your muscles the more you practice it. The more you grow your muscle memory, the easier and freer your writing will become.

BASIC POINTED BRUSH STROKES

To get started, just play with the brush to see what it can do. Make up shapes and designs; have fun with it!

Once you're used to the brush tip marker, start practicing downstrokes and upstrokes. The downstrokes are thick, and the upstrokes are thin. You make these by changing the amount of pressure you use on the brush, as well as the tilt of the brush in the writing hand. Lay the brush flatter for a thick stroke, and tilt it up on its very tip for a thin stroke. Don't worry, this gets much smoother and easier the more you practice.

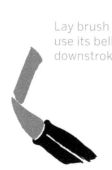

Lay brush flat and use its belly for downstrokes.

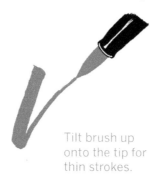

Tilt brush up onto the tip for thin strokes.

As you practice your strokes with the brush tip marker, keep these hints in mind:

✦ Use light pressure (even on heavier downstrokes) when writing with your brush pen. Very heavy pressure will damage your marker tip.

✦ Use a weight, height, and slope for your downstrokes that you can easily keep up the whole time you're writing.

✦ Try basing your forward slope (how much the letters lean) on your own handwriting. Just don't slope your letters backward because that crunches the letter forms and makes them look like they are falling back rather than sailing forward.

✦ Be careful to start and end every stroke with a pause and pressure. This will help you make clean terminals (the ends of each stroke).

✦ Pull the brush instead of pushing it.

NOPE!
Stroke started without pressure.

NOPE!
No pause with pressure before ending the stroke.

YEP!
Start and end each downstroke deliberately and with pressure.

✦ Write a thin stroke that you can comfortably repeat by releasing pressure and rocking onto the tip of your brush, and that creates a good contrast to your thick downstrokes.

✦ Lively brush calligraphy looks like it is written quickly and loosely, but you will need to keep a sharp eye on your brush as it dances along the paper.

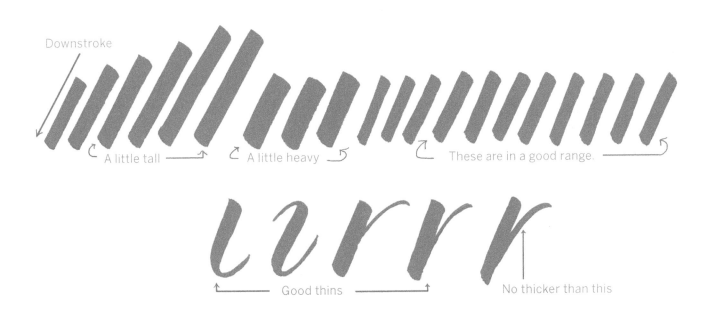

Downstroke

A little tall

A little heavy

These are in a good range.

Good thins

No thicker than this

The first alphabet you'll practice here is based on the *Italic* hand. There are two more pointed brush hands in this chapter for you to discover: *"Happy"* on page 36 and *"Bold & Brassy"* on page 38. You can understand an alphabet best by arranging it into groups of letters that have similar strokes and shapes. We call these groups "families." Before you practice these with the brush, it's a good idea to lay a piece of tracing paper over the letters and trace them with a pencil to get a feel for their special shapes and how they are formed.

INDIVIDUAL LETTERS

The "a" related family: "a," "d," "g," "q," "b," and "p" ("b" and "p" are the "a" shape upside down).

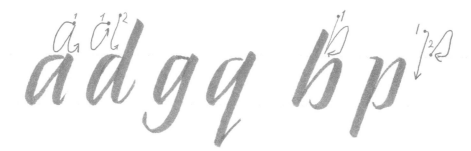

The straight and narrow family: "i," "l," "j," "t," and "f."

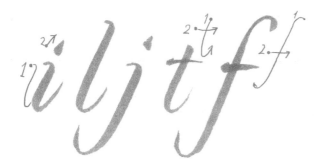

The "o" related family: "o," "c," "e," and "q" variation.

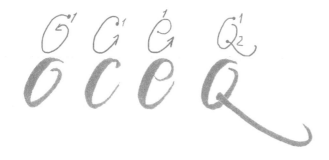

The "n" related family: "n," "m," "r," "h," "k," "y," and "u" ("y" and "u" are upside-down "n" shapes).

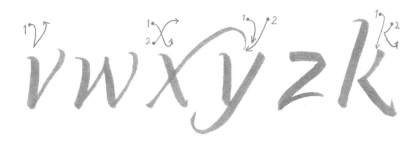

The diagonals family: "v," "w," "x," "y," "z," and "k."

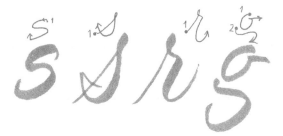

And the odd ones: "s," "r," and "g."

CONNECTING LETTERS

Now let's look at connecting the letters. Even though you need to pause before forming the connecting upstroke, you want your words to look like there was no break in the writing. Connectors should look like the upstrokes in your letters—this will automatically keep the right spacing between your letters. Remember that the connecting stroke should reach almost up to the waistline of the next letter, not across the bottom.

The "hand reaching out" is where we join these letters with the next letter.

a a c d e h i k l m n r t u x b b b b s s p p

One-stroke "e"

Two-stroke "e"

The "e" can join in two different ways.

t t f e g o o r v w w y y z g j q

Double crossbar

butterfly wings

These strokes should match.

To join from a descender, add a flourish or don't connect to next letter.

Curve down a bit into a smile shape to connect from the waistline.

Look at the examples of how each letter likes to connect to the following one. You can think of it as a letter reaching out its hand to connect with the next.

TIP: Connecting strokes and upstrokes are always thins. This contrast with the thick downstrokes gives a good visual rhythm to your work.

BOUNCE YOUR LETTERS!

The technique of making your letters bounce is super popular right now. It looks carefree and fun, and it is! You can become an expert at it by following a few simple rules:

Write your word in brush or pencil. Mark the downstrokes. These are the strokes that can go below the baseline for bouncing. Now try your word. Remember to bring the connector strokes up to their proper place, even if the downstroke was lengthened. Narrow your word a little so it is easier to read.

Add this little trick: Make your "o's" and "a's" a little smaller, and let them rise up to the waistline once in a while. After you have tried these rules on your word, look it over. Does everything look good? Are there too many long downstrokes too close together? If so, redesign your word to look more balanced. Now write it on your project and watch it bounce!

TIP: Lowercase, or minuscule, letters have three possible parts: the main body of the letter, called the x-height; the part going up from the x-height, called the ascender; and the part extending below the x-height, called the descender.

1. Write your word in pencil.

Watch it bounce

2. Mark the downstrokes.

Watch it bounce

3. Extend the downstrokes below the baseline.

Watch it bounce

Too many extended downstrokes next to each other. Don't alter both legs of a letter.

4. Look it over, and choose which extended downstrokes to keep and which to undo to make it look balanced.

Exaggerate where you can. Try reducing the size of a letter or two.

Watch it bounce

This could be exaggerated.

5. Now try it with your brush.

Watch it bounce!

Brush Italic Lowercase

*Release pressure at these points.

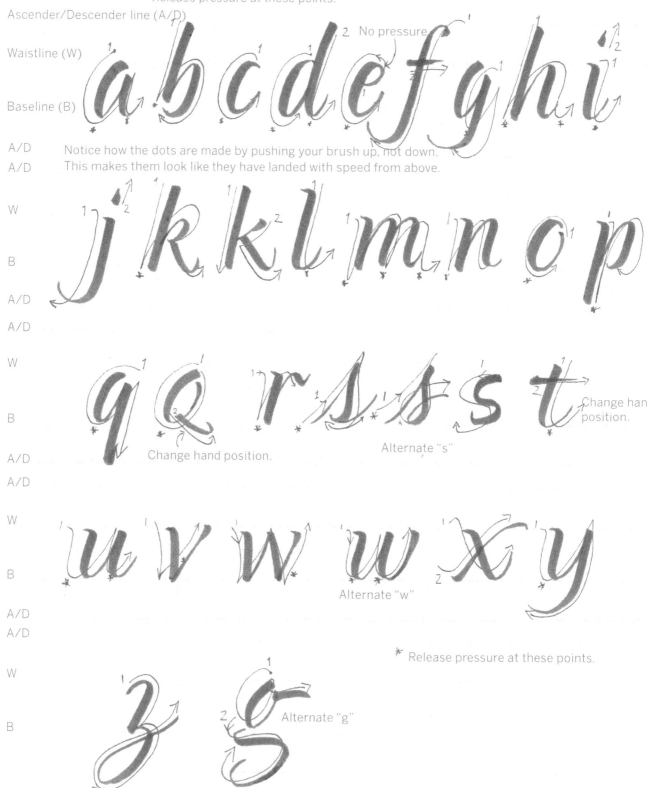

Ascender/Descender line (A/D)

Waistline (W)

Baseline (B)

A/D Notice how the dots are made by pushing your brush up, not down.
A/D This makes them look like they have landed with speed from above.

W

B

A/D

A/D

W

B Change hand position.

A/D Alternate "s"

A/D Change hand position.

W

B Alternate "w"

A/D

A/D

*Release pressure at these points.

W

B Alternate "g"

No pressure

Ascender/Descender line (A/D)

Waistline (W)

Baseline (B)

A/D

W

B

A/D

W

B

A/D

W

B

A/D

W

B

Brush Italic Capitals

A A B C D E F
G H H I J K
L M M N N
O P Q R S T
U V W W X
X Y Z

*You can pause at the bottom of these strokes on "v" and "w" if you feel more comfortable doing it that way.

0 1 2 3 4 5 6 7 8 9

Happy

An informal pointed brush alphabet with a loose feel and a light slope

a b c d e f g h i

j k l m n o p q r

s t u v w x y z z

0 1 2 3 4 5 6 7 8 9

A B C D E F G

H I J K L M N

O P Q R S T

U V W X Y Z

Bold & Brassy

LOWERCASE

A pointed brush alphabet, short and heavy, with a slight slope or no stroke

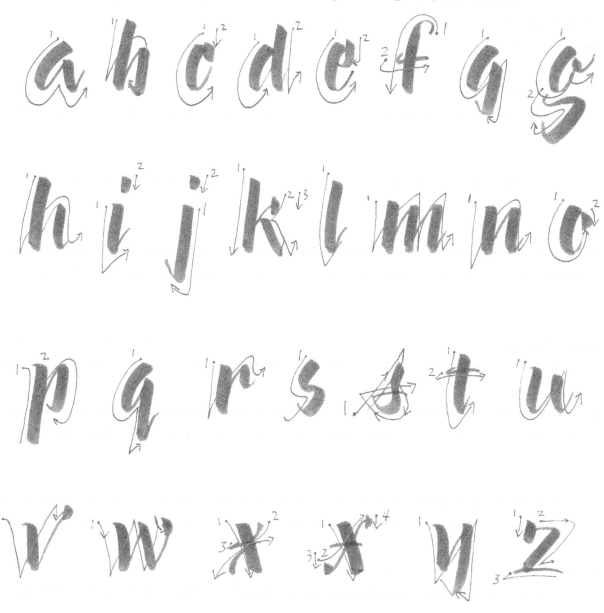

Ascender/Descender (A/D)

Waistline (W)

X-height (X)

Baseline (B)

A/D

W

X

B

A/D

W

X

B

A/D

W

X

B

A/D

W

X

B

A/D

W

X

B

A/D

W

X

B

A/D

W

X

B

Bold & Brassy

CAPITALS

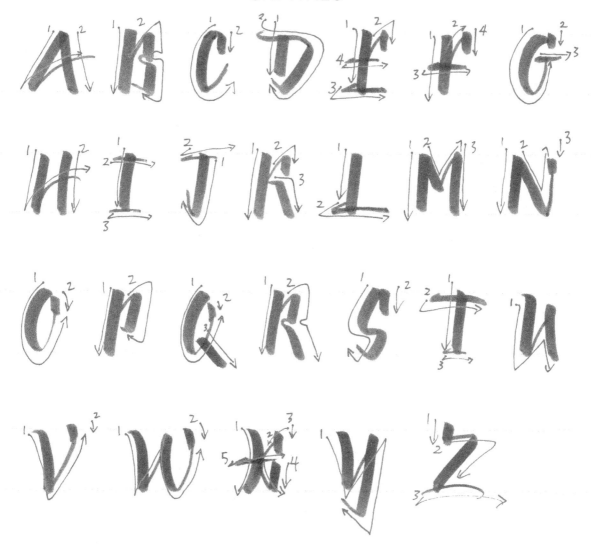

Four

Monoline Calligraphy

You will love monoline alphabets! "Monoline" simply means every stroke of each letter is the same thickness. This makes the letters look very different from the other styles you are learning. They are great to use on their own or to mix things up in a piece you design with other alphabets. And with monoline calligraphy, there are no worries about pen angle or brush pressure. Whew!

In this chapter, we will focus on one monoline calligraphy hand, *Running Roman*, based on the Roman hand from the Renaissance. There are two more monoline alphabets for you—*Posh & Polished* and *Neuland*—on pages 50 and 52 at the end of this chapter. Each hand has a lot of room for you to experiment by making small changes to fit your own personality.

Monoline letters look fresh and modern. They can be wispy and thin or thick and chunky. Dress them up with outlines and inlines, bounce them, surround them with flourishes . . . anything goes! These are playful letterforms, and they're just waiting for your creativity to bring them to life.

Holding Your Marker Pen

One fun thing about monoline letters is that you can create them using almost any marker, chalk, pen, or pencil. Still, it helps to have the right tools.

For small writing, you can use any round or bullet tip marker. Almost any colored markers, like Crayola markers, will work well. For thicker, bigger writing I like the Posca Paint Pens (see page 14).

You might be working with a tool you are already very familiar with for regular writing or drawing, but let's take a quick look at the best way to hold it for calligraphy.

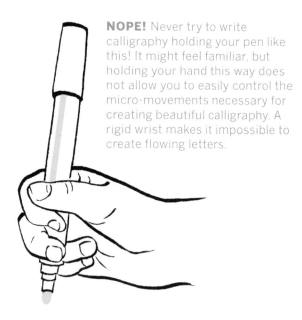

NOPE! Never try to write calligraphy holding your pen like this! It might feel familiar, but holding your hand this way does not allow you to easily control the micro-movements necessary for creating beautiful calligraphy. A rigid wrist makes it impossible to create flowing letters.

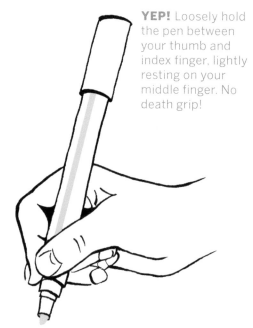

YEP! Loosely hold the pen between your thumb and index finger, lightly resting on your middle finger. No death grip!

Making the Strokes and Letters

In monoline calligraphy, the strokes you write have no thick or thin parts to them, so you won't need to worry about tipping your marker like you do for brush lettering—you don't have to watch your pen angle like you do in classic calligraphy. You just need even pressure and speed as you write each stroke. Sounds pretty easy, right? But don't forget, this is still calligraphy! You will need to carefully craft each letter and follow a few basic rules as you write.

Practicing with pencil is a good way to get comfortable with these letters. Don't erase on your practice pages, though; just try again right next to your mistake. When you look over your page, look for your best letters and be proud of how much progress you are making.

INDIVIDUAL LETTERS

Running Roman is a fun little alphabet that looks very different from the others. It has a tiny x-height, and extra tall and long ascenders and descenders. It can be connected like a script or printed as separate letters. You can stretch it way out like a rubber band or squish it tightly together.

Let's look at a few of this hand's unique letters here:

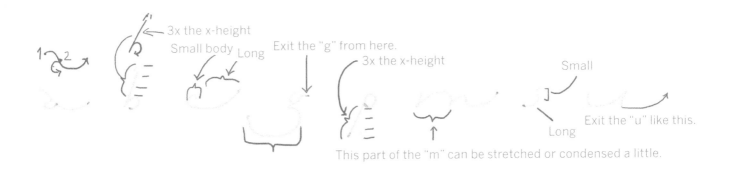

The body of these letters is round, short (x-height), and narrow (look at "c").

The ascenders, descenders (look at "b" and "p"), and exit strokes are about three times as long as the body of the letters.

CONNECTING LETTERS

One of the most important parts of monoline writing isn't even a letter! The connector stroke is the bridge that reaches from one letter to the next, like in cursive handwriting. In monoline lettering, the connector is the same thickness as the other strokes, so you need to be sure to give it all the room it needs. These strokes are very important to your writing's overall look. They can stretch a word out super long or condense it tightly.

Following the same rules from chapter 3, where each letter reaches out a hand to the next, let's write a word.

Notice that when you stretch out a word, you keep the letters basically intact and lengthen the connecting strokes.

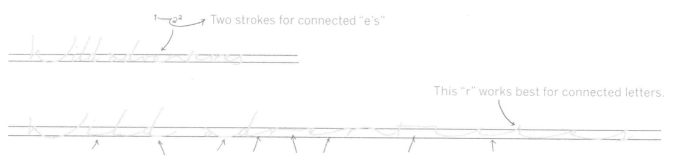

Two strokes for connected "e's"

This "r" works best for connected letters.

Going off-road:

This is a good exercise for your mind, eyes, and fingers. It can be used with any letterforms, but monoline capitals work really well.

1. With a thin marker, draw several wavy lines on your paper for the capitals' baselines and cap height, like this:

2. Draw your capitals in a thicker black marker inside your guidelines, making them vary in height and width according to the space inside your lines.

3. Now use colored pencils or crayons to color some of the spaces inside and between letters like this:

Running Roman

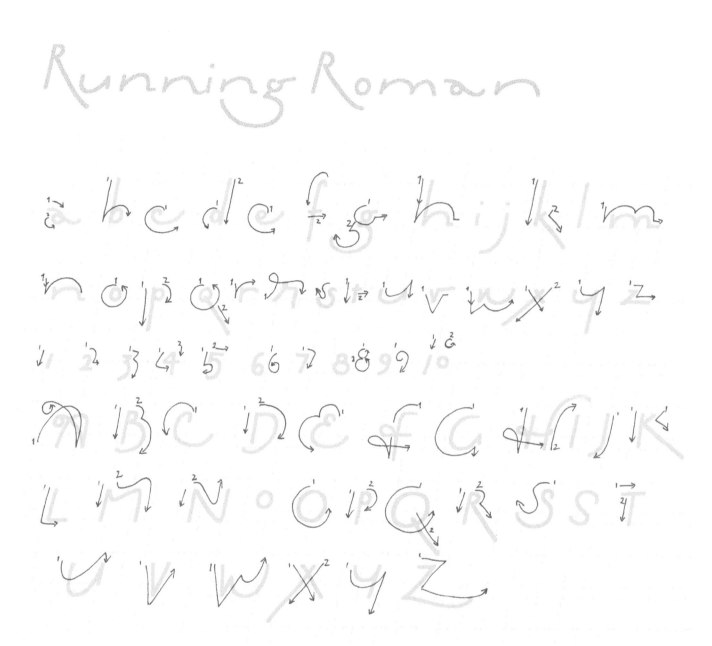

The small x-height in relation to the long ascenders and descenders makes this alphabet really stand out. Most counters are circular rather than oval, and it can be slanted forward or written with no slope, however works best for your piece.

Ascender/Descender line (A/D)

Waistline (W)
Baseline (B)

A/D

W
B

A/D

W
B

A/D

W
B

A/D

W
B

A/D

W
B

A/D

W
B

A/D

W
B

A/D

W
B

A/D

Posh and Polished

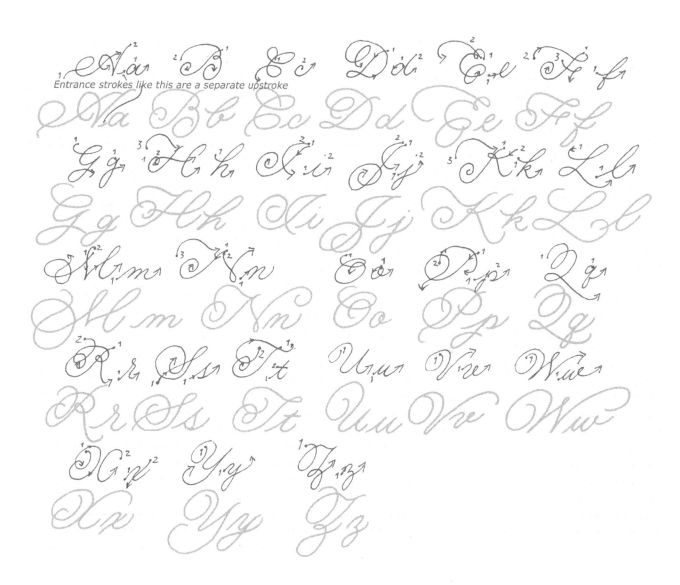

Entrance strokes like this are a separate upstroke

This hand is based on the Copperplate Style, originally written with a pointed flexible nib.
Notice the "a" shape and "o" shape are both based on an oval, not like with Italic.
Also the big flourishes of the capitals are based on ovals.

Ascender/Descender line(A/D)

Waistline (W)
 X-Height X
Baseline (B)
A/D

W
B X

A/D

W
B X

A/D

W
B X

A/D

W
B X

A/D

W
B X

A/D

W
B X

A/D

W
B X

A/D

W
B X

A/D

W
B X

A/D

W
B X

A/D

W
B X

A/D

W
B X

A/D

W
B X

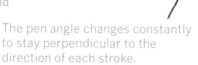

NEULAND

This alphabet is based on a 1923 alphabet by Rudolf Koch. It can be short and heavy or tall and thin. It is an all capitals alphabet, and demands attention!

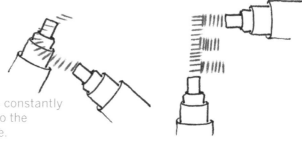

The pen angle changes constantly to stay perpendicular to the direction of each stroke.

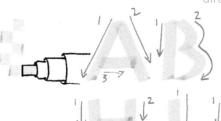

Try breaking strokes:

Try outlines:

Copy just the outline and fill in with watercolors.

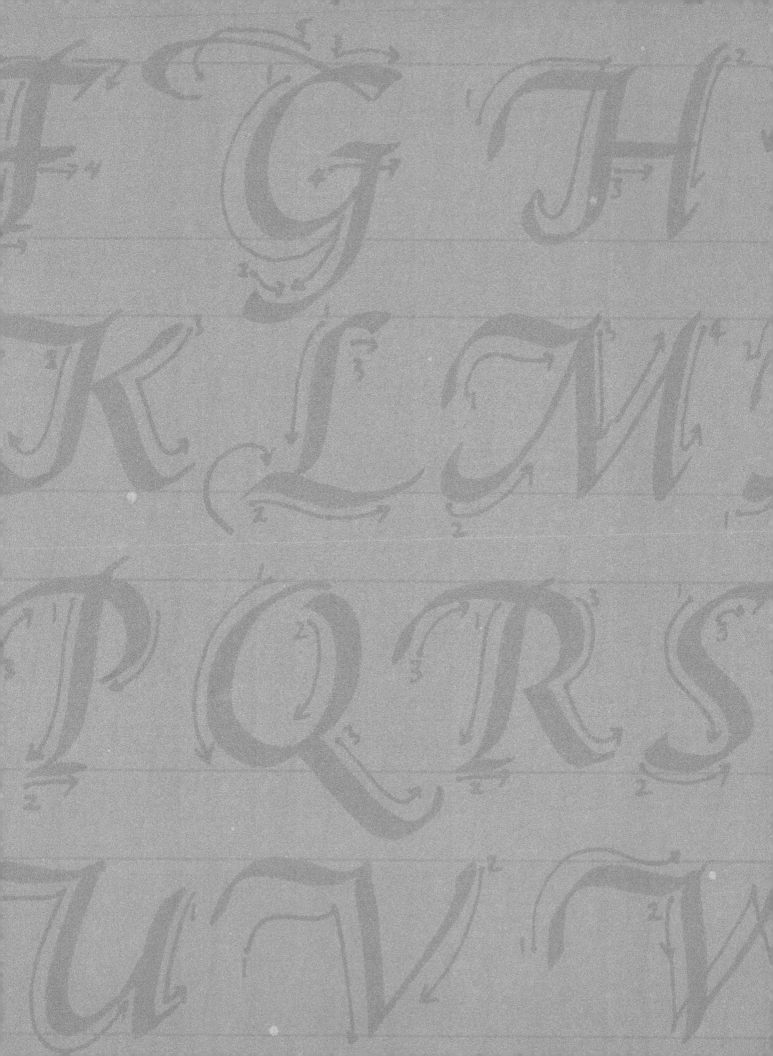

Five
Traditional Calligraphy

At last! Here you are, ready to begin writing elegant and enduring traditional calligraphy. These letters are made with the broad edge, or chisel edge, pen. The way the edge of your pen touches the paper determines your stroke's thickness or thinness. A stroke's weight change is the most beautiful element of calligraphy. It makes your writing striking and impressive. You will love the flow of the pen as it forms these letters, and with practice, you can become an expert.

There are many styles, or hands, of traditional calligraphy. In this book, you will be introduced to three of them. We'll start with the *Italic* hand in this chapter and move on to the *Uncial* and *Gothic* hands on pages 68 and 70 at the end of this chapter. These are significant writing styles from past centuries that are hugely popular in today's design world. They are used anywhere a distinctive, formal, or elegant look is needed—for example, in certificates, diplomas, greeting cards, logos, and fancy invitations. The best way to capture the beauty of these letters is to be very strict with yourself and closely follow instructions for pen angle, letter shape, and slope. Paying close attention to the samples will help you understand how all these elements come together to create the finished letter.

Holding Your Calligraphy Marker

The most important part of writing traditional calligraphy is holding your calligraphy marker the right way.

Let your marker pen rest in your hand. Hold it firmly enough to control it, but lightly enough to move it easily along the paper. Your wrist should rest very lightly on the table so that it is free to move as you make the strokes.

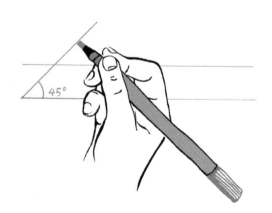

These letters are made with your whole hand and arm, not just your fingers.

Start your practice with a 3.5-mm tip. The wider edge makes it easier to feel your pen angle and to see if your tip is making a solid line on the paper. The tip of your chisel edge calligraphy marker has two corners you need to be aware of. When you drive a car, you need to make sure all four wheels are always touching the ground if you want to avoid disaster. Similarly, you need to make sure both corners of your marker tip are always on the paper for the entire stroke, especially on the curves.

NOPE! Right edge not on the paper.

NOPE! Left edge not on the paper.

YEP! Good even pressure on both edges.

Making the Strokes and Letters

The *Italic* calligraphy hand has four distinct features:

- ✦ It uses a diagonal pen angle.
- ✦ Each letter leans forward.
- ✦ The shape of the letter "a" and its family group is very important.
- ✦ The letters and words are placed very close together but don't necessarily touch.

MASTERING THE PEN ANGLE

Let's get familiar with the pen angle first. We refer to the diagonal angle as a 45-degree pen angle. If you draw a square and cut it in half diagonally, that line is on a 45-degree angle. Writing with a pen angle means holding the edge of your marker tip in line with a 45-degree diagonal line, not flat with the straight line you're writing along. You'll need to twist the right corner of your tip up to be in line with the diagonal. Like this:

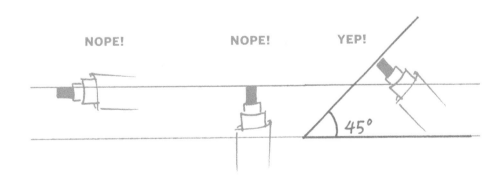

NOPE! NOPE! YEP!

45°

Place your marker tip on your paper at that 45-degree diagonal pen angle and draw some straight lines down. Try some plus signs and some zigzags. Be careful to keep the exact same pen angle as you draw each stroke.

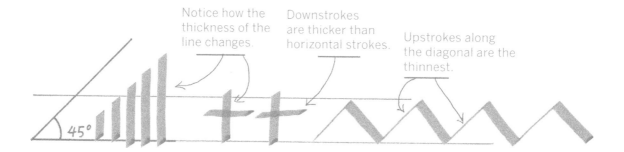

Notice how the thickness of the line changes.

Downstrokes are thicker than horizontal strokes.

Upstrokes along the diagonal are the thinnest.

Now try some waves, hills, and diamonds, and see what happens. It is fun practice designing borders with patterns like these. Keep a calligraphy marker handy so you can play with it anytime you would otherwise be doodling—in class, watching shows, or hanging out with friends.

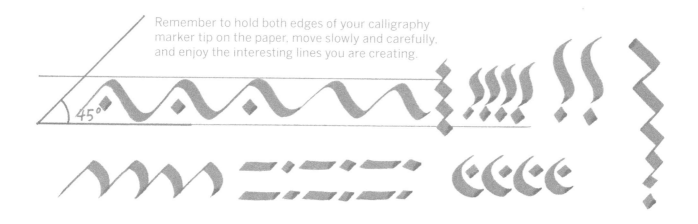

Remember to hold both edges of your calligraphy marker tip on the paper, move slowly and carefully, and enjoy the interesting lines you are creating.

INDIVIDUAL LETTERS

The second distinctive feature of *Italic* letters is their slope—that is, *they lean forward a little, just like these typed letters are doing now.* Your practice pages have lines to follow for the slope, as well as lines for the x-height, ascenders, and descenders. Pay close attention to the slope as you practice and soon this hand will feel comfortable and natural.

Hairlines are another type of mark you can learn to create with a pen angle. Hairlines are the super thin lines on the entrances and exits of the letters (like the thin lines on your zigzag practice). They help your letters look graceful and light, rather than clunky. You make them by sliding your marker tip upward along the diagonal line at the start and finish of the letters.

Now, let's look at the letters in their family groups of similar shapes. It is best to get to know these shapes with a pencil before you tackle them with your calligraphy marker.

The "i" family is made of straight lines.

i l j t f

This is the "a" shape family:

a d g q

b p

The "b" and "p" are upside down "a" shapes.

The "a" shape is a softened triangle lined up along the slope line. This is the most distinctive shape of the *Italic* alphabet.

Branching stroke

n h m r y u k

The "n" related family uses a branching stroke to form the humps of the letters.

The tricky thing about these is that the counters, rather than the letter strokes, are lined up with the slope line that bisects the triangular counter. Like this:

The diagonals family:

v w x y z k

o e c s

The "o" related family is based on an oval, not a circle. The "s" fits into the "o," so it is related.

These are the two-stroke letters:

a l d e f k p p s t x o

An "s" can be a single stroke or two strokes.

An "o" can be a single stroke or two strokes.

SPACING THE LETTERS

Unlike the hands we learned in the last two chapters, traditional calligraphy alphabets don't connect the letters together. Instead, the letters in each word have a common slope, size, and spacing and similar strokes to make them feel related.

WIDTH OF ITALIC LAYERS

NOPE! These letters are too wide.

NOPE! These letters are too narrow.

YEP! These letters are a good width.

smile *goofy* *shine*

INTER-LETTER SPACING

NOPE! This is spaced too far apart.

NOPE! These are too close together.

YEP! This is spaced just right.

silly *squeeze* *sparks*

Italic letters are pretty narrow, with a shape based on an oval rather than a circle. Each letter (except "i," "l," and "m") needs to be the same width, and the space between letters needs to be about the same as the space inside letters.

Words in a sentence can be spaced closely, too. Try to leave just enough room for an "n" between words. Like this:

INTER-WORD SPACING

Dream and wonder

Leave just enough space for an "n" to fit between words.

Italic

Need to know:
Pen angle=45° diagonal
X-height=5 pen nibs
Slope=5°

Ascender line

Waistline

Baseline

Descender

a b c d e f g

g h i j k k l m

n o p q r s t

u v w x x y z

0 1 2 3 4 5 6 7 8 9

MODERN CALLIGRAPHY FOR KIDS

Italic Swash Capitals

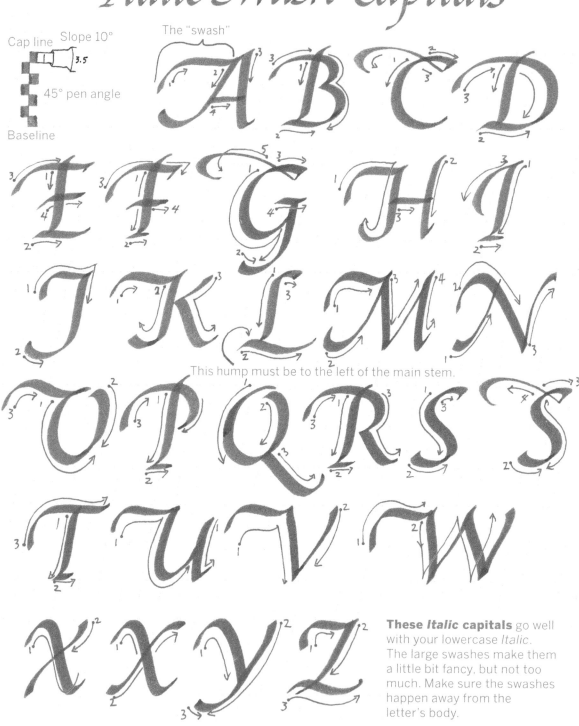

Cap line Slope 10° The "swash"

3.5

45° pen angle

Baseline

This hump must be to the left of the main stem.

These *Italic* capitals go well with your lowercase *Italic*. The large swashes make them a little bit fancy, but not too much. Make sure the swashes happen away from the letter's body.

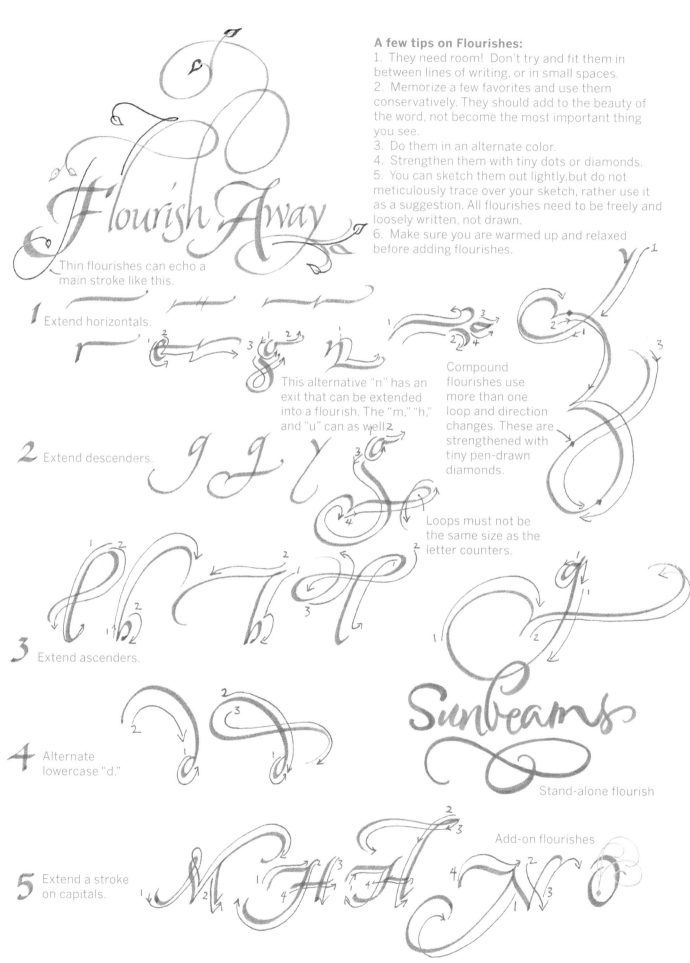

Flourish Away

Thin flourishes can echo a main stroke like this.

A few tips on Flourishes:
1. They need room! Don't try and fit them in between lines of writing, or in small spaces.
2. Memorize a few favorites and use them conservatively. They should add to the beauty of the word, not become the most important thing you see.
3. Do them in an alternate color.
4. Strengthen them with tiny dots or diamonds.
5. You can sketch them out lightly, but do not meticulously trace over your sketch, rather use it as a suggestion. All flourishes need to be freely and loosely written, not drawn.
6. Make sure you are warmed up and relaxed before adding flourishes.

1 Extend horizontals.

This alternative "n" has an exit that can be extended into a flourish. The "m," "h," and "u" can as well.

Compound flourishes use more than one loop and direction changes. These are strengthened with tiny pen-drawn diamonds.

2 Extend descenders.

Loops must not be the same size as the letter counters.

3 Extend ascenders.

4 Alternate lowercase "d."

Sunbeams

Stand-alone flourish

5 Extend a stroke on capitals.

Add-on flourishes

UNCIAL

Uncial ("UN-shull") is a very old alphabet from the fourth century. People didn't have minuscules yet, so all of these letters are capitals. Some look more like minuscules because the alphabet was always changing. They are written with a new, flatter pen angle and can have a tiny x-height. They can be as small as 3 pen nibs high, but we will start out with them at 4 pen nibs high.

Need to know:
Pen angle=10°–20°
X-height=2.5–4 pen nibs
No slope

The pen angle is 10–20 degrees, which is what we call a "flat pen angle." This is what distinguishes the *Uncials* as much as the letter shapes. Start your practice with the pen exercises in chapter 5, pages 57 to 58. When you are comfortable with this new pen angle, start on the letters here.

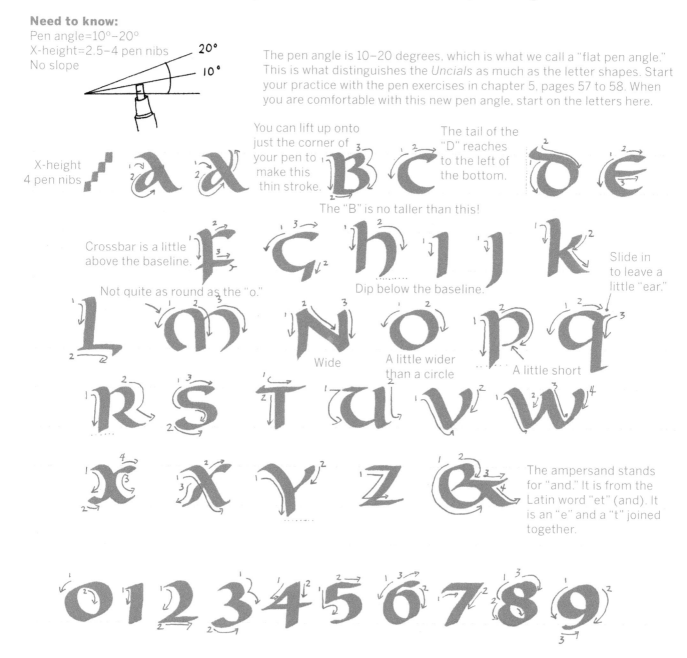

X-height
4 pen nibs

You can lift up onto just the corner of your pen to make this thin stroke.

The tail of the "D" reaches to the left of the bottom.

The "B" is no taller than this!

Crossbar is a little above the baseline.

Not quite as round as the "o."

Dip below the baseline.

Slide in to leave a little "ear."

Wide

A little wider than a circle

A little short

The ampersand stands for "and." It is from the Latin word "et" (and). It is an "e" and a "t" joined together.

Gothic Lowercase

The Gothic alphabet developed by the 14th Century out of the need to condense writing so more could fit on each page. It squeezed the letters into shapes that could be written quickly and with just a few strokes. It was so compressed that it made the pages look black with ink and is a family of writing called "Blackletter." The pattern or design of the word, line, or page is more important than any single letter. Spacing and stroke repetition is your key to perfecting this beautiful hand.

Need to know:
Pen angle 45°, Diagonal
X-Height 4–7 pen nibs
No slope (0°)

Basic strokes: Gothic lowercase uses just a few basic strokes over and over to build the letters.

These diamond shapes are used as entrance strokes, dots, periods and decorations.

Pause or stop as you join strokes.

"Foot" or exit stroke. These are often a little longer.

Make hairline strokes by sliding your marker along the 45° pen angle.

Practice spacing your strokes. You can set the marker tip down in between each stroke as you write to check your spacing. Practice by writing taller than what you need, then drop down to the x-height.

Strokes need to be spaced evenly, with the white space between strokes the same as the black of the stroke. Practice this until it becomes natural and rhythmic.

Too widely spaced.

Too closely spaced.

Just right!

Alternate is drawn with the corner of your marker tip.

Slide pen.

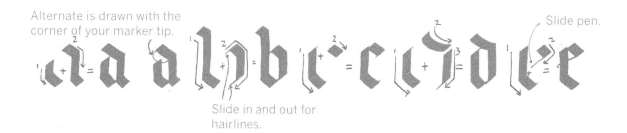

Slide in and out for hairlines.

Draw with the corner of your tip.

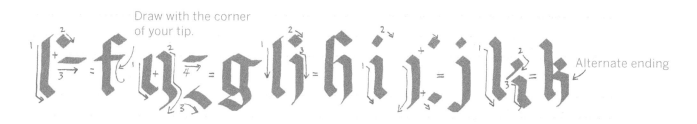

Alternate ending

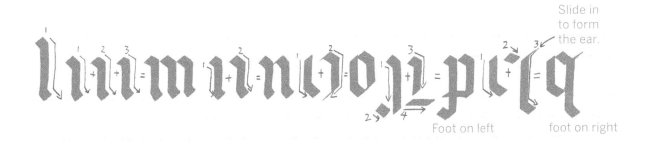

Slide in
to form
the ear.

Foot on left foot on right

Two possible tops for the "s."

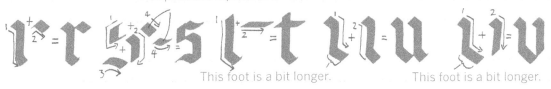

This foot is a bit longer. This foot is a bit longer.

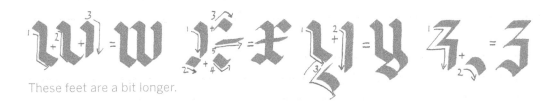

These feet are a bit longer.

For Gothic, switch to your smaller (2mm) nib as soon as you have mastered the letters. You will love writing small Gothic. Historically, this was the first alphabet to start dotting the "i." Do the exercise to the right to understand why.

MODERN CALLIGRAPHY FOR KIDS

Gothic Capitals

The Gothic alphabet is the first one to develop its own set of Capital letters to match its lowercase letters. There are many forms to choose from. I am including the basic ones here. They can be decorated, or written extra-large to start out a paragraph. Try practicing them by writing names, with the lowercase. Have fun with them!

Decorative strokes

These three strokes can be added to the left top of a capital as decoration.

This "thorn" is embedded in vertical strokes. See the "J."

Turn pen like this for these vertical hairline embellishments.

Diamond

This stroke is used to help fill an open space, like on the "D."

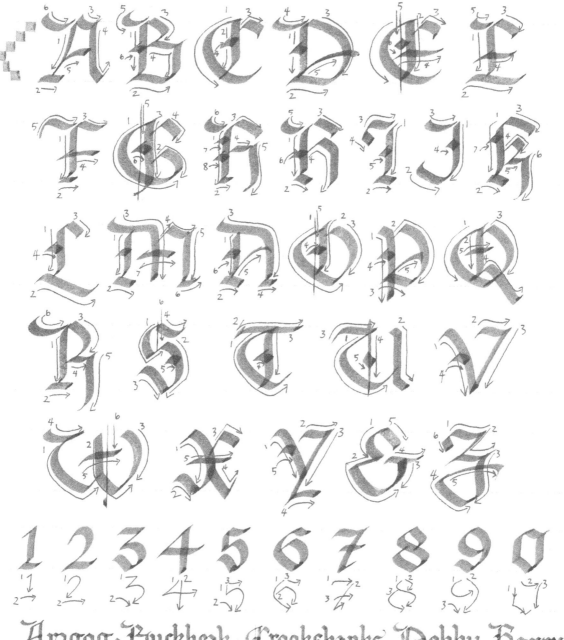

Aragog · Buckbeak · Crookshanks · Dobby · Harry

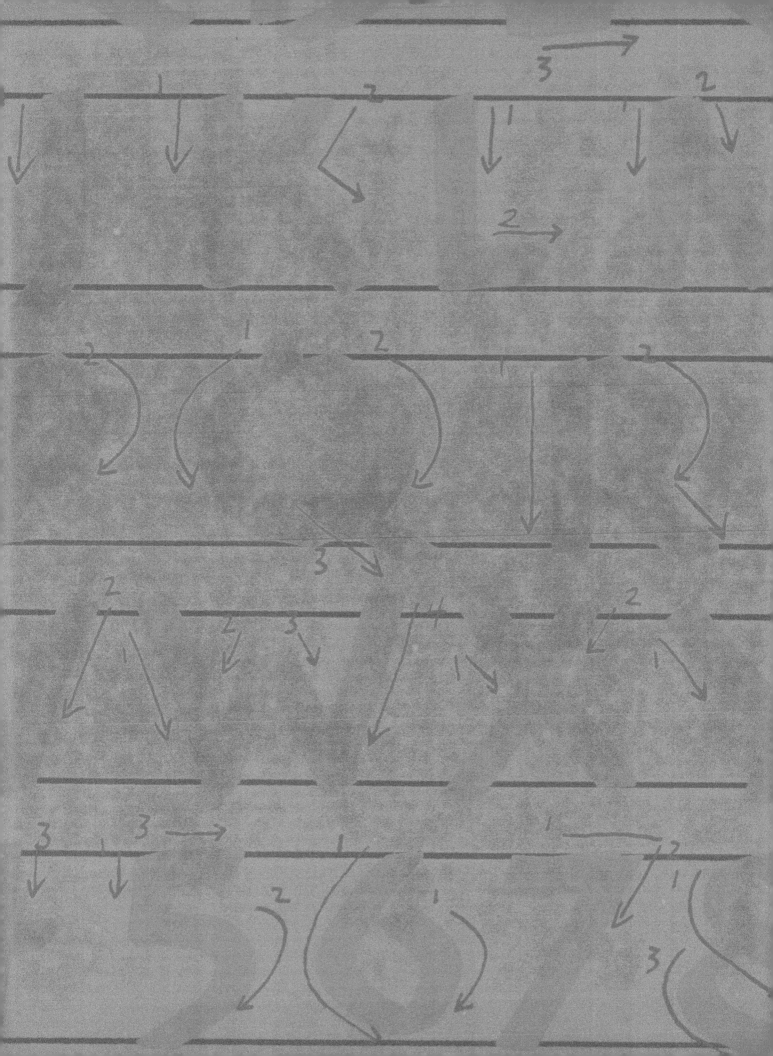

Six
Projects

By now, your fingers are probably itching to create something "real" with all your new calligraphy skills. Good news—you're ready! Here are some ideas for pieces you can create, no matter how perfect or imperfect you might consider your calligraphy.

Even the best calligraphers make mistakes, so I've included some suggestions to make things easier and help you avoid common errors. Each project has a materials list, a step-by-step guide, a tip or two, a hand to copy for the project, and a photo of the finished piece. Once you are familiar with the process for each project, use it to come up with your own ideas. Change the wording or style however you like! The idea is for you to fill your own world with beautiful and unique calligraphy.

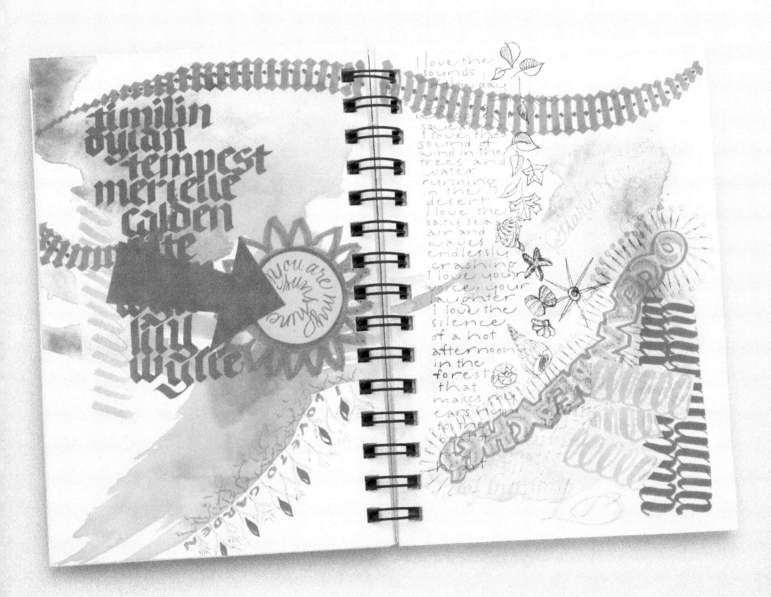

Just a Few Favorite Things

In this project, we will spice up a journal page with calligraphy. Journals are a great way to keep track of your thoughts, ideas, dreams, and experiences. They are kind of like your photo stream online, but you can include scribbles, sketches, lists, colors . . . whatever comes to mind! You can create the pages based on how you feel each time you sit down. Your journal becomes a peek inside your brain for any given day.

Your journal can be pocket-sized to carry everywhere or hefty enough to hold your biggest ideas. You might want one that comes with guidelines, dots, or grids if you are going to do a lot of calligraphy—or you might prefer blank pages for more free-form work, allowing you to draw guidelines only where you need them.

My favorite journals are mixed-media blank books. These have thick paper that works well for paint, pencil, or markers. They also work better for gluing in things like photos, magazine cutouts, or movie tickets.

You Will Need:

A journal (Don't have one yet? Use a sheet of heavy paper.)

Watercolor or acrylic paints

Paintbrush

Old calligraphy practice pages to cut up

Scissors or X-ACTO knife

Glue stick

Old toothbrush, for splatter painting (optional)

Calligraphy markers: brush tip, bullet tip, and chisel edge, various sizes

Alphabets: all your favorites

How to Fill the Journal

1. Start thinking of things you like: food, activities, books, people, places, or things.
2. Mix water into your paints so they are nice and liquid. Now take your biggest brush and dip it into clean water. Using large free strokes, brush water onto a double spread of pages. Do this in brush strokes, leaving lots of dry spaces. To add color, dip smaller brushes into your wet paints and let the paint drop into the puddles of water left by your big brush strokes. The colors will run and bleed into each other, but will stay within the shape of your watery brush stroke. This will leave a colorful background of shapes to write within, around, or over with your calligraphy.

3. While your paint is drying, find some old calligraphy practice pages with a lot of strokes or letters on them. Cut a few small shapes out of them to arrange on your journal pages.
4. When your paint is dry, glue on your practice paper shapes with the glue stick, overlapping them in some places. Be sure to leave plenty of painted spaces showing. If you like, splatter the pages with paint using a paintbrush or toothbrush.
5. Now make a border with your favorite practice strokes. By writing over the layers of glued and painted areas, you can make a 3D look!
6. Finally, add words to your page. Name some of your favorite things. Write them down in different calligraphy styles and sizes. Use a lot of different marker tips.

TIP: When designing a collage of shapes and colors like this, place things close together and leave some open spaces where there is nothing.

Merielle Quill
1829 Daisy Circle
Winton, Ohio
4 6 3 7 5

COME JOIN THE
Party!

Hey! It's a Party, and You're Invited!

Create a very special invitation for a special event. You can personalize this any way you want. Your guests will know they're an important part of the upcoming event when they open your handmade invitation!

You Will Need:

Paper A, colored or patterned paper, cut to 6½ x 9 inches and folded in half to 6 x 4½ inches, like a little tent

Ruler

Pencil

Paper B, paper in a color lighter than the first, size 5 x 3½ inches

Paper C, white or light-colored paper size 5 x 4 inches

Scratch paper

Calligraphy markers: size 2.5 mm chisel edge marker, brush markers of different colors, and bullet tip markers for monoline writing

Eraser

Glue stick

Alphabets: *Brush Italic* and *Running Roman*

How to Make the Card

1. On *Paper B,* draw a light baseline and a line for the cap height (how tall the capital letters will be). The cap line is ½ inch from the top of the paper, and the baseline is ¼ inch below the cap line.
2. Also on *Paper B,* draw another baseline for the large word "Party" about 2 inches from the top of the paper.

Paper B, 4½" x 3" Baseline ¾" from top

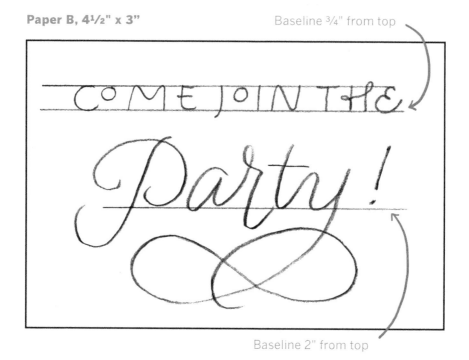

Baseline 2" from top

3. On scratch paper, write out the words "COME JOIN THE" in *Running Roman* capitals with a bullet tip marker (use one color or several). When you have it written in a size that will fit on your guidelines on *Paper B*, pencil it onto your good paper and write it in marker. If you want, move your writing off center to make room for decorative stickers, etc.

4. On scratch paper with a brush tip marker, write the word "Party" in *Brush Italic*. Add a flourish below it to fill the space. When it is the right size, carefully pencil this onto your *Paper B*. Write over the pencil in brush tip marker.

5. Using your ¼-inch pencil border on *Paper A* as a guide, make a calligraphic border with your chisel edge markers all around the front of your card.

6. Line *Paper C* with three baselines for small writing in *Running Roman* capitals and lowercase. Measure down from the top: at 1¼ inches, 2¼ inches, and 3¼ inches. The x-height for these baselines should be ⅛ inch high.

7. On the first line inside, write the time and date of the party. On the second line, write the place where the party will be held. The last line can have any other information your guest needs to know, like "Bring your skateboard" or "Shhhh! It's a surprise for Ryder."
8. Wait for the ink to dry, then use your eraser to carefully remove any pencil marks.
9. Glue *Paper C* to the inside of folded *Paper A*. Glue *Paper B* onto the front of *Paper A* with a glue stick, and you're done!

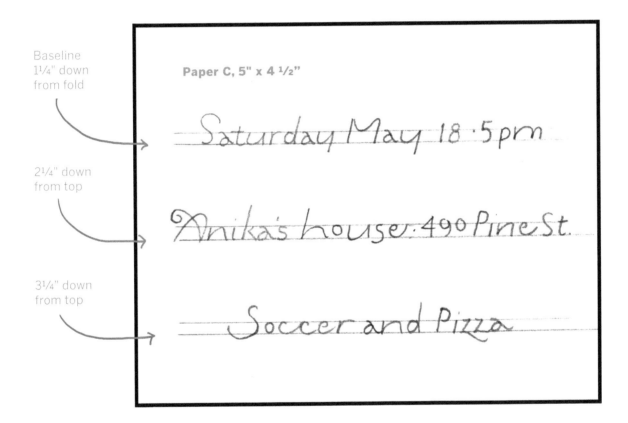

Baseline
1¼" down
from fold

Paper C, 5" x 4 ½"

2¼" down
from top

3¼" down
from top

Saturday May 18 · 5pm

Anika's house · 490 Pine St.

Soccer and Pizza

TIP: Don't glue anything together until you have the calligraphy done the way you want it. That way you can write it over a few times if you need to.

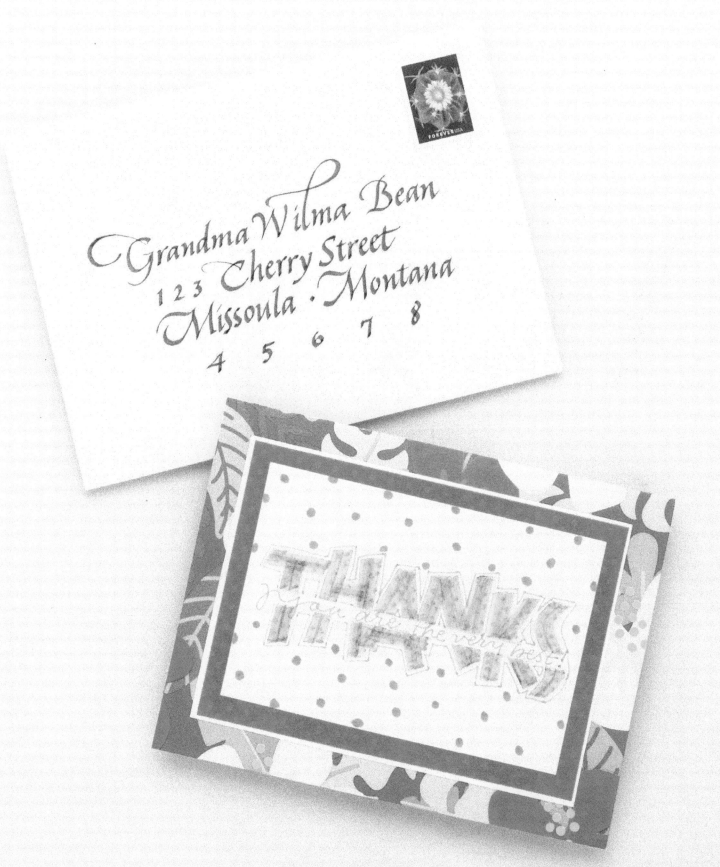

Grandma Wilma Bean
1 2 3 Cherry Street
Missoula · Montana
4 5 6 7 8

THANKS
You are the very best!

A Sweet Note in the Mail: Old-School Style!

After your party, send this handmade thank-you card in the mail. Anyone you send this to will feel warm and special knowing the time and thought you put into it just for them. You will make their trip to the mailbox extra sweet.

For the Card, You Will Need:

Paper A, colored paper, size 4½ x 3 inches. You might want a couple extras for mistakes.

Pencil

Masking tape, painter's tape, or patterned paper cut into a 5-inch-long strip at ⅛ inch wide

Calligraphy markers: your largest chisel edge marker and a fine bullet tip marker

Scratch paper

Eraser

Glue stick

Paper B, colored paper in a second color, size 6 x 9 inches, folded in half to 6 x 4½ inches, like a little tent

Paper C, colored paper in a third color, size 5 x 3½ inches

Alphabets: *Posh & Polished* and *Neuland*

For the Envelope, You Will Need:

Heavy-weight white paper to make template for address, cut to size
6 x 8½ inches

Chisel edge marker, size 2 mm

Ruler or T-square

A few envelopes made out of paper that won't bleed, size A-6 , 6½ x
4⅝ inches (envelopes should be about ¼ inch larger than your card)

Pencil

Eraser

Alphabet: *Brush Italic*

How to Make the Card

1. On your small piece of paper, *Paper A*, lightly pencil the word
 "THANKS!" using *Neuland* letters (see page 52). Make your word as
 large as will fit and center it.
2. Lay the strip of tape lengthwise over your word and lightly smooth
 it in place. You will write your large letters over the top of this line of
 tape as if the tape weren't there.

Place the thin
strip of tape
over your word.

3. Take your largest chisel edge marker and write *Neuland* letters for the word "THANKS!" Make them as thick as will fit by double stroking each stroke.

Write your word in pencil, then place the thin strip of tape over it and write it again in marker.

4. Be sure to let the tops and bottoms of each letter reach above and below the tape line.

TIP: All this work for just one card? Make several at a time and leave out the inner message to add later. Variation: Try stacking words together and using your new tape trick to make one or more lines for writing. The *Neuland* alphabet is great for this. It is dense, so it remains legible when you leave space inside it like we did for the card, and if you use colors, they really show up!

5. Remove the tape slowly and carefully so that you don't tear the paper. You now have a writing line within your word to write anything you want.

Carefully pull the tape away.

6. Set a piece of scratch paper below your new writing line. With your pencil, write out your message on the scratch paper in small cursive *Posh & Polished*. Spread the message out as wide as you need to in order to fill the space. (Remember to lengthen the connector strokes instead of stretching out the letters themselves.) Use the scratch paper, pencil, and eraser to get the size just right.

7. Using the scratch paper as your guide, in very light pencil, copy your message as accurately as you can onto the writing line inside the word "THANKS!" Double-check the spelling and write it again with your fine bullet tip marker. (By the way, did you misspell "THANKS!" on your first attempt? If so, that is a very typical calligrapher's mistake—we don't always misspell words, but when we do, we do it boldly!)

Write your message in pencil, then in marker. Erase.

Now you are ready to glue your papers together to complete your card.

8. Now put *Paper B* flat in front of you with its folded edge on top. Glue *Paper C* to the center of *Paper B*. Center *Paper A* (with your message) on top of *Paper C* and glue it in place. Your message should be on the outside cover of your card with the fold on top, and the edges of the three different paper colors should make nice borders around your message. Impressive!

Glue *Paper A* to *Paper C*, then glue these two to *Paper B* with the fold on top.

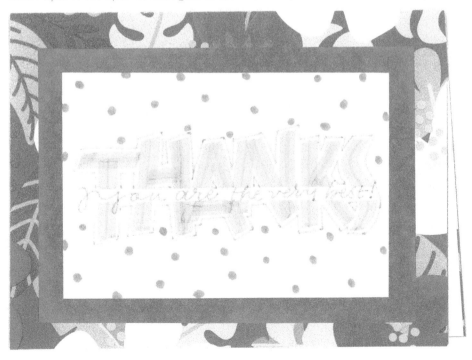

Addressing the Envelope

9. To draw baselines for the address, set the white piece of paper vertically in front of you. Use a black bullet tip marker and a ruler or T-square. Starting 1 inch from the bottom of the paper, draw five lines, one above the other, ½ inch apart.

TIP: One option is to lightly draw lines for the address right onto your envelope. Set a stamp on first so that you're sure to leave room for it!

10. Place this paper inside your envelope so that you can see your guidelines through the front of the envelope.
11. In light pencil, write your address using the guidelines. Remember that the numbers need to be spaced a little farther apart than letters in a word.
12. Write over your pencil in marker. Wait until the ink is very dry, then erase carefully with a good eraser.

VARIATIONS: Enlarge just the name. Draw wavy or diagonal lines for the address. Line up the address lines on a straight left-hand margin, or make a slanted guide so the start of each line of the address is slightly indented below the line above.

TIP: You might be interested in the Graceful Envelope Contest. You can enter an envelope or get inspired by the many past winners on the contest website, CalligraphersGuild.org.

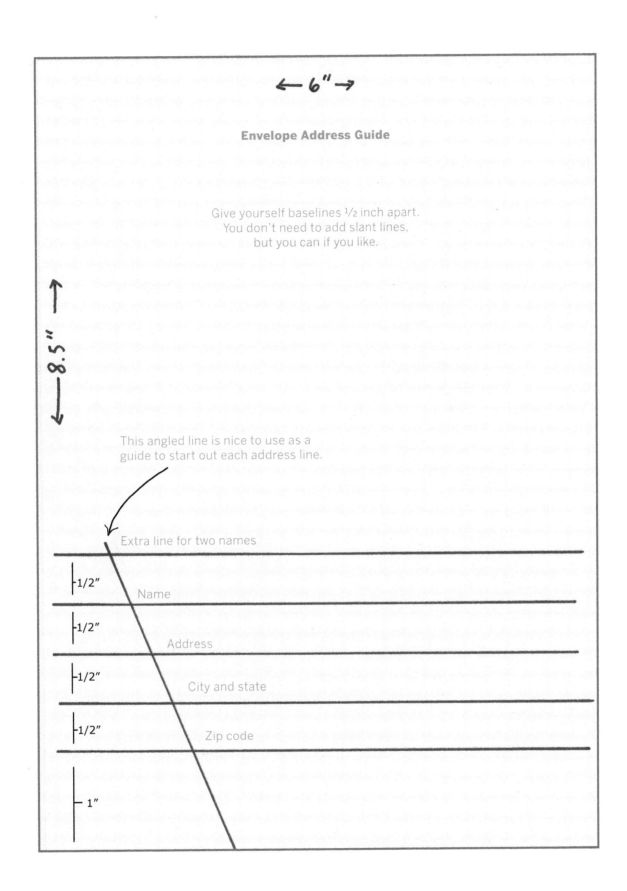

← 6" →

Envelope Address Guide

Give yourself baselines ½ inch apart.
You don't need to add slant lines,
but you can if you like.

8.5"

This angled line is nice to use as a
guide to start out each address line.

Extra line for two names

1/2" Name

1/2" Address

1/2" City and state

1/2" Zip code

1"

← 6" →

Envelope Address Guide

Let the front of your guide show through on the front of your envelope. Pencil in your address.

This method is for addressing a lot of envelopes.

You can be creative with your arrangement of the address; just make sure that it is legible and the zip code is alone on the bottom line.

Grandma Wilma Bean
1 2 3 Cherry Street
Missoula · Montana
4 5 6 7 8

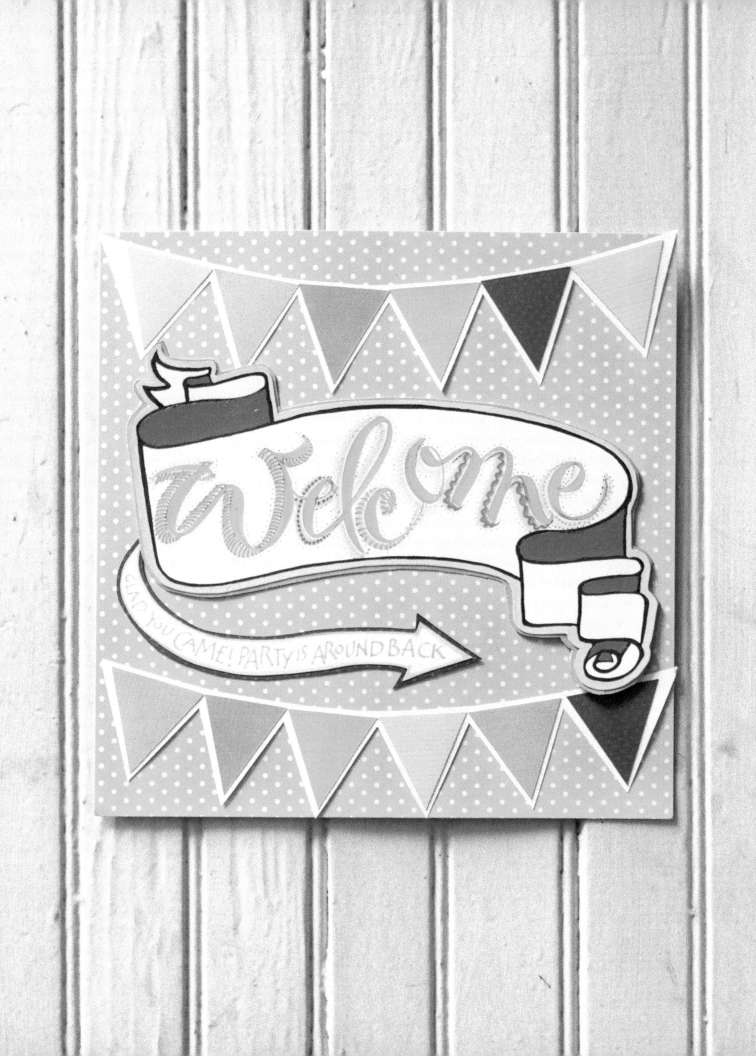

Welcome

GLAD YOU CAME! PARTY IS AROUND BACK

Signs That Stand Out

You can make this welcome sign for your family's front door or maybe for your room. (You might need a second sign saying "Stay out, please!" if it's on your own room, though!)

You Will Need:

Banner pattern

Paper A: one white or light-colored piece of card stock, 8½ x 11 inches, or a photocopy of the banner pattern printed onto an 8½-x-11 inch piece of heavy paper

Pencil

Calligraphy markers: brush tip marker pens in dark colors, smaller bullet tip markers

Scissors

Glue stick

Paper(s) B: a 12-x-12 inch piece of patterned card stock, or two 8½-x-11 inch pieces of colored card stock overlapped and taped together to make one sheet of 11-x-14 inch paper.

Alphabet: *Bold & Brassy*

How to Make the Sign

1. Use the pattern to draw a banner shape on *Paper A*.
2. Lightly pencil the word "Welcome" as large as it will fit inside the banner shape. When you have it just right, use your brush tip marker to write over the pencil in *Bold & Brassy*. Use a lot of pressure on the downstrokes so they turn out bold.
3. Decorate your letters any way you like.
4. With a wide marker, make a heavy border over the penciled banner shape. You can go over it again to make it even thicker if you like.
5. Color in the shaded areas of the banner with a color you haven't used yet.
6. Cut out the banner shape, leaving as much of the border as possible.
7. Glue this banner shape to *Paper B*.
8. Add more decorative touches to your sign if you like. Next, cut the backing *Paper B* to the size you like.
9. Your sign is done, and it is fantastic!

VARIATION: Add other information to your sign on smaller, bordered signs of different colors, layering them for eye-catching information.

TIP: Borders are pretty tricky to draw and can mess up a nice piece of calligraphy. I always make my sign a little smaller than my space so that I can glue it onto a larger paper that makes a border around it.

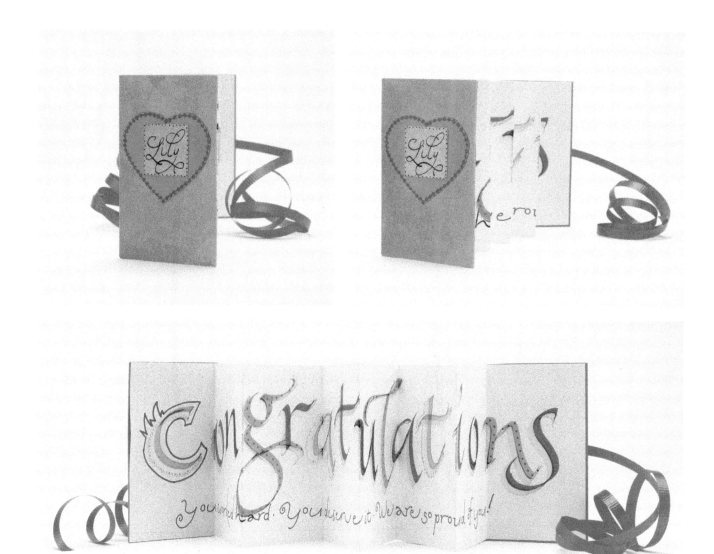

MODERN CALLIGRAPHY FOR KIDS

A Tiny Book of Congratulations

Bookmaking is an old and precise craft. Each fold needs to be crisp and straight for everything to fit together. Even a tiny booklet like this, when carefully made, lets loose a bit of magic and delight when opened.

You Will Need:

An 11 x 14 inch (legal size) piece of good copy paper or art paper, not too thick, cut into a long horizontal piece that's 14 x 3 inches

Pencil

Calligraphy markers: brush tip, bullet tip, and chisel edge, various sizes

Eraser

Sheets of card stock in multiple colors

Scissors or X-ACTO knife

Glue stick

A thin ribbon or string about 18 inches long

Alphabets: *Classic Italic, Running Roman,* or your own handwriting

How to Make the Booklet

1. Fold your long paper carefully into an accordion using the accordion method shown on page 102.
2. Fold in half so the short ends touch, and crease your fold. Open it up

so the fold is a valley fold (with the crease resting on the table), not a mountain fold (with the crease lifted up off the table).

3. Take the right end and carefully line it up into the center crease. Fold and crease the new right edge. Repeat with the left side.

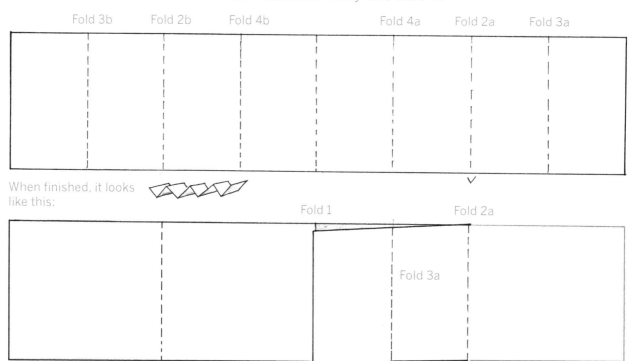

4. Now take the right-hand edge that is lined up in the center and fold it back to the right-hand fold. Crease. Repeat with the left side.
5. Now turn your paper over so the center fold is a mountain fold. Don't unfold. Take the right folded edge that is uppermost and line it up with the center fold. Fold and crease. Repeat with the left side. Now you have a straight, clean accordion fold, good for all sizes of little booklets.
6. Open it up and lightly pencil the word "Congratulations!" You can tilt your letters if you want, but keep them separate and don't connect them. Leave some room at the bottom for a personal note. Write "C" on the first page and two letters on each following page. Like this:
7. Trace over "Congratulations!" in various marker colors.
8. Decorate the letters. You can use inlines, outlines, or shadows. You can make them each different or all the same.

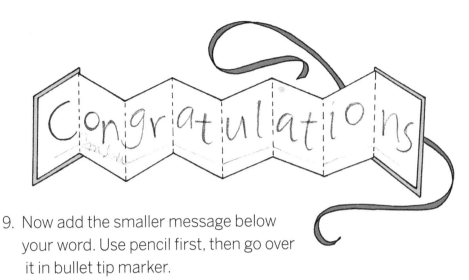

9. Now add the smaller message below your word. Use pencil first, then go over it in bullet tip marker.

10. Let it dry before erasing your pencil.

Dress up your letters!

Shadow your letters by giving them a pretend light source and keep the shadow on the opposite side of each stroke.

Inlines

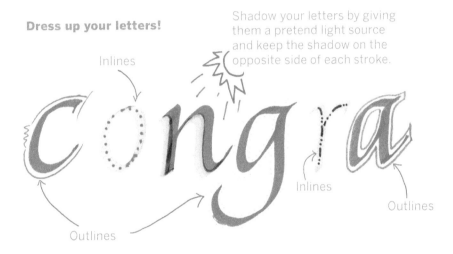

Outlines

Inlines

Outlines

Outlines

11. Set your folded booklet on the back side of the card stock and lightly trace around it. Cut two of these rectangles (make them a little larger than your tracing) for the covers. They should be about 2 x 3¾ inches.

12. Glue the covers onto the outside front and back of your book.

13. Cut a little rectangle of a different card stock for your book title. Your title can be the name of the person you're giving the book to or just a design, but it is good to have something there so that people know which way to open the book. Make sure you glue it right-side up onto the page that has the "C" on the other side.

14. Glue the middle of the ribbon down on the back cover so that the ends are free; now you can tie your book shut.

15. Whew! You made it! "**Congratulations!**" is right!

VARIATION: You can make an accordion book any size. Just experiment with the sizes, and glue more strips of paper together to create books with more pages.

Glossary

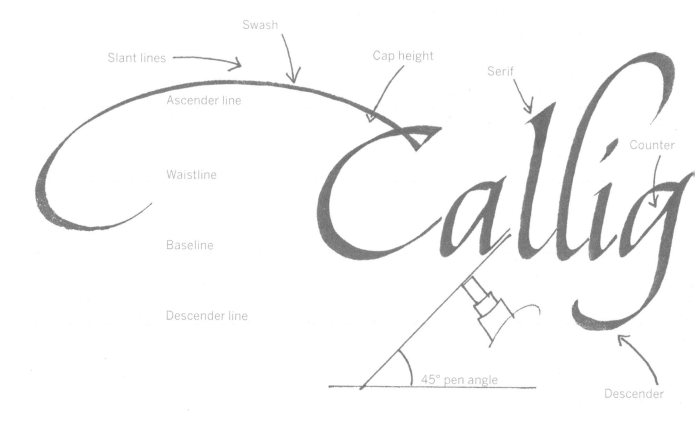

Ascender: The part of lowercase letters that reaches above the waistline or x-height; the letters "d," "f," "h," "k," and "l" have ascenders (note that "t" is shorter, so it doesn't have an ascender).

Ascender line: The guideline that marks the top of where the lowercase letters' tallest part will reach; in a page of guidelines, the ascender line is also the descender line for the writing above it.

Baseline: The main writing line that the letters sit on.

Branching stroke: A stroke in the *Italic* hand; this stroke starts at the baseline and springs out to form the hump part of letters in the "n" family group.

Broad edge: A pen tip with a wide or chisel edge.

Cap height: How tall capital letters are. This is generally a little shorter than the ascender line.

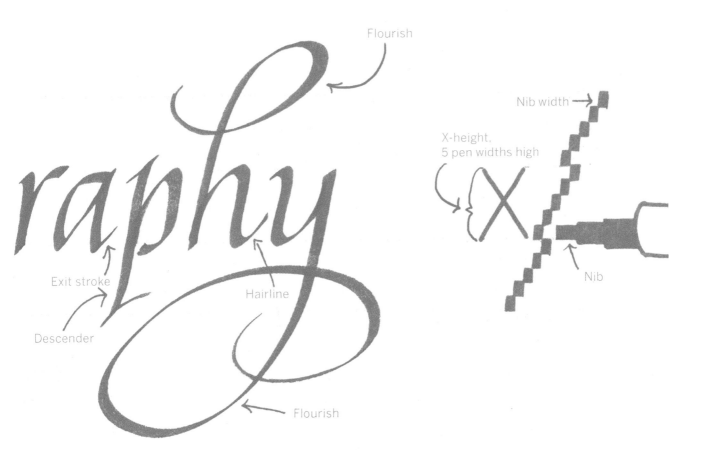

Compound curve: A stroke that begins and ends with a thin stroke; it starts with an upstroke, rounds over the top at the waistline, forms a thick downstroke that curves off the baseline in a thin upstroke; it can be a form within a letter, or it can be a stroke that joins the exit from one letter to the entrance of the next letter.

Counters: The inside spaces of letters; "O" has a closed counter, "C" has an open counter.

Crossbar: A thin horizontal stroke found on lowercase "t" and "f," and sometimes on capitals "A," "E," "F," "G," and "H."

Descender: The part of lowercase letters that reaches below the main writing line; the letters "f," "g," "j," "p," "q," "y," and "z" have descenders.

Descender line: The guideline that marks the bottom of where the lower-case letters' lowest part will reach; in a page of guidelines, the descender line is also the ascender line for the writing below it.

Downstroke: The part of the letter made by the pen or brush moving downward on the paper; this is usually the letter's thickest stroke.

Entrance stroke: The small hairline stroke that starts the letter; it is usually an upstroke.

Exit stroke: The small hairline stroke that ends the letter; it is usually an upstroke.

Family group: The name for the group of letters in an alphabet that are made with similar strokes and shapes.

Flourish: An added stroke or loop used to decorate letters.

Guidelines: The code for how to size your letters; guidelines show the baseline, x-height, ascender height, descender length, and slope angle.

Hairline: The thinnest stroke made with the writing tool.

Hand: A style of calligraphy.

Letterforms: The forms or shapes of a letter.

Majuscule: Another name for capital, or uppercase, letters.

Manuscripts: Handwritten books or documents.

Minuscule: Another name for lowercase letters.

Nib: The tip of a pen or marker.

Nib width: The common way to measure a letter's height; the size of the mark that a chisel edge tip will make held at 90 degrees to the writing line (the number of these nib widths from the baseline to the waistline equals the x-height).

Overturn: A stroke that starts with a hairline upstroke and thickens as it turns downward.

Pen angle: How a chisel edge tip lines up in relation to the baseline (for example, the edge can be completely in line with the baseline, or it can be tilted to a diagonal pen angle of 45 degrees); this angle controls the width of each stroke.

Sans serif: A letter with no extra strokes (like feet and hats) on its ends; "sans" means "without."

Script: A hand that is written like cursive, where the letters connect and slant forward.

Serif: A small decorative stroke that looks like feet or hats that are added to the end of a letter's main strokes.

Slant line or slope line: The line on the guidelines that reminds you how much your letters should lean forward.

Spacing: The amount of room between letters (inter-letter), between words (inter-word), or between lines of writing (inter-linear).

Strokes: Lines or marks made with a writing tool.

Underturn: A stroke that starts thick and thins to a hairline as it turns upward.

Upstrokes: The strokes made by moving the pen or brush in an upward motion on the paper; these are generally thin hairline strokes.

Waistline: The line marking the top of the x-height.

Weight: The thickness of a letter's strokes in relation to their height.

X-height: The distance between the baseline and the waistline, and the height of a lowercase letter without an ascender or descender; named this way because the height of "x" is easiest to measure. The other letters at this height are "a," "c," "e," "i," "m," "n," "o," "r," "s," "u," "v," "w," and "z."

Index

Acknowledgments

Modern Calligraphy for Kids is a work of love that I created with the inspiration and support of many people. These include the scribes who worked centuries ago, my first handwriting teacher (who wore a flowing nun's robe that swayed as she wrote cursive letters on the chalkboard), and contemporary calligraphers who have taught me with kindness, patience, skill, and humor.

I especially thank Mike Gold, who taught me to be creative without losing the true nature of calligraphy; and my first calligraphy teacher, Annie Cicale, who formally introduced me to this beautiful writing. Special teachers like Georgia Deaver, John Stevens, Carl Rohrs, Georgia Angelopoulos, Peter Thornton, Julian Waters, Laurie Doctor, Yves Leterme, and Brody Neuenschwander have filled me with excitement about art and expressing myself artistically, inspiring me with new ideas to create with my pen. Thank you to my longtime students for challenging me, cheering me on, and always supporting me: Virginia, Becky, Amity, Marion, Ann, Deb, Jewel, Linda, and Wilma. Thank you to my children who continue to teach me to be creative.

Finally, I thank my brilliant and generous daughter, Timilin Sanders, who helped turn my scrambled early drafts into the clear chapters you are reading today.

About the Author

Sally Sanders lives in the Western United States. It is a land of beautiful mountains, endless sky, towering sandstone, and wide-open desert, which she depicts in her art. She is a professional calligrapher and artist with nearly 40 years of experience working for individual customers, and large and small companies. Her work in calligraphy includes elegant invitations to major city events and small country weddings, as well as powerful signs for protest marches.

Sally has taught children and adults for over 35 years, and is continually inspired by her students. She finds that kids in particular know the magic of a written message and love to use calligraphy to express themselves on paper. She teaches calligraphy to keep the art form alive and growing, and to keep herself involved in current, exciting projects.

Most important to Sally is her family, ranging in age from one to 93. "From them, I learn love, which is both the object of my creative fire and its source."

CPSIA information can be obtained
at www.ICGtesting.com
Printed in the USA
BVHW090108281121
622588BV00001B/1